All rights reserved. No part of this publication may be reproduced, distributed, or transmitted in any form or by any means, including photocopying, recording, or other electronic or mechanical methods, without the prior written permission of the creator, except for purposes of review and other non-commercial uses permitted by copyright law. DON'T BE A JERK!

Illustrated by KARLA MAGAÑA

Copyright 2019 Karla Magaña

STARDUSTSPACELUST COLORING BOOK

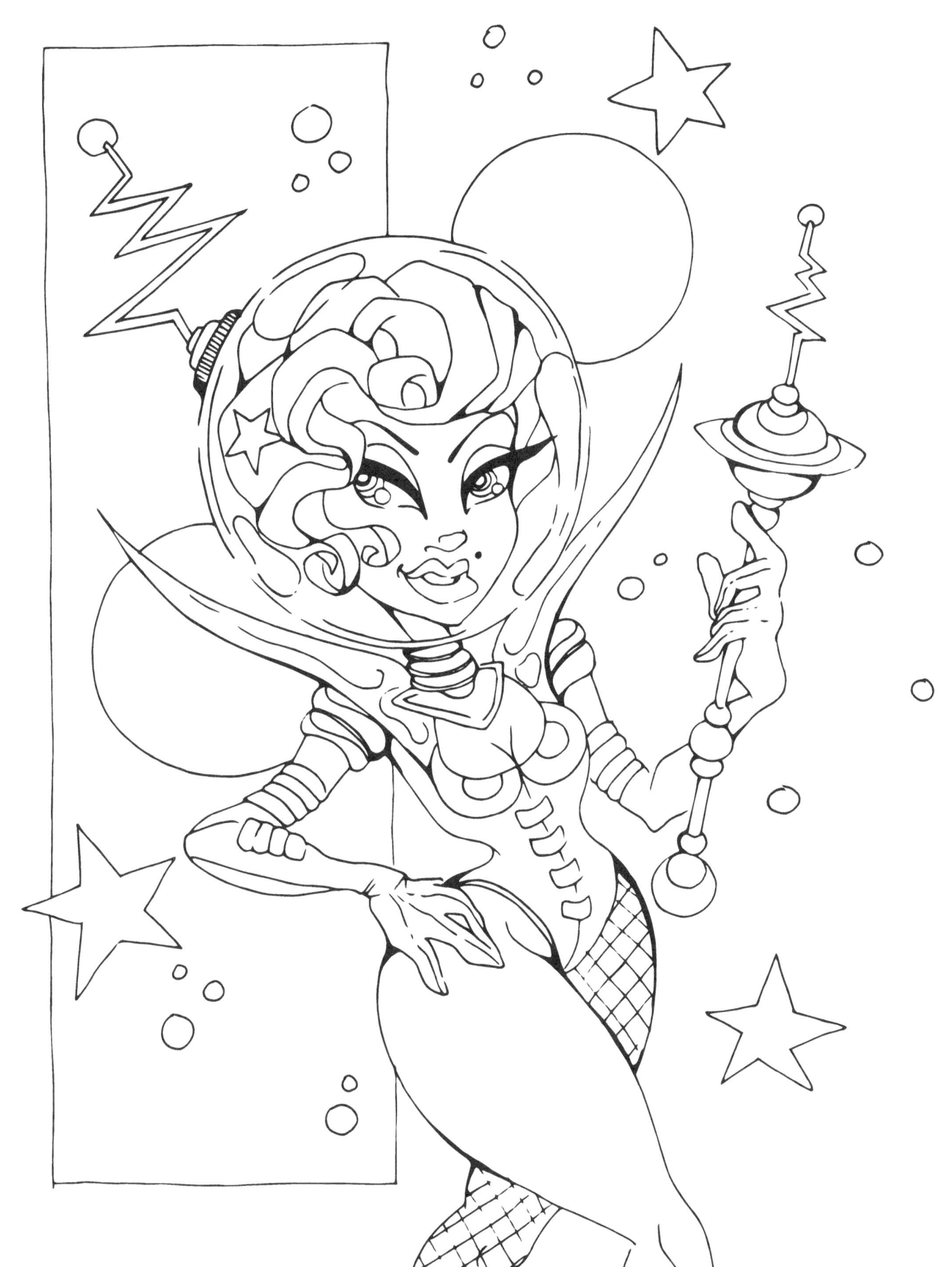

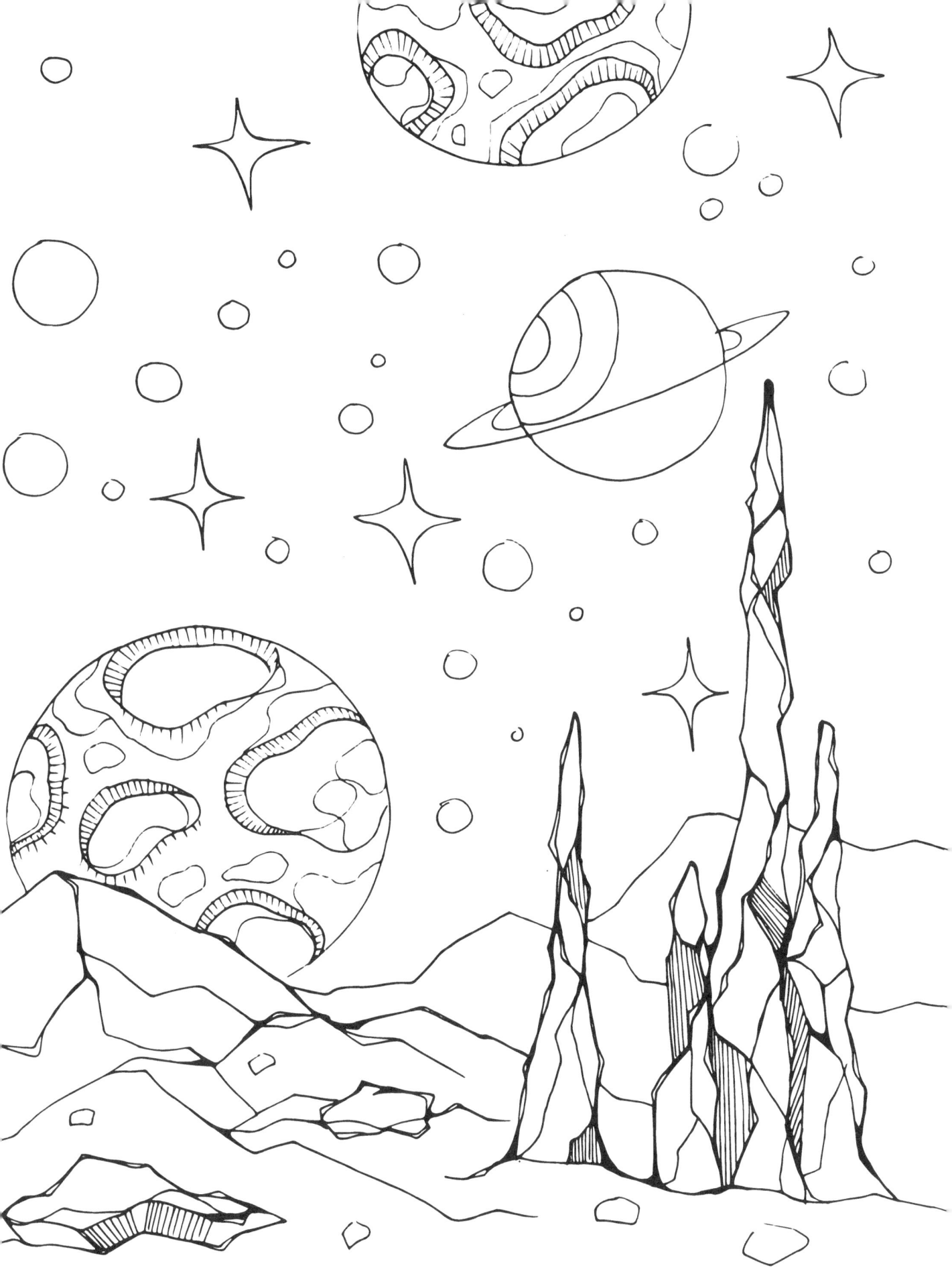

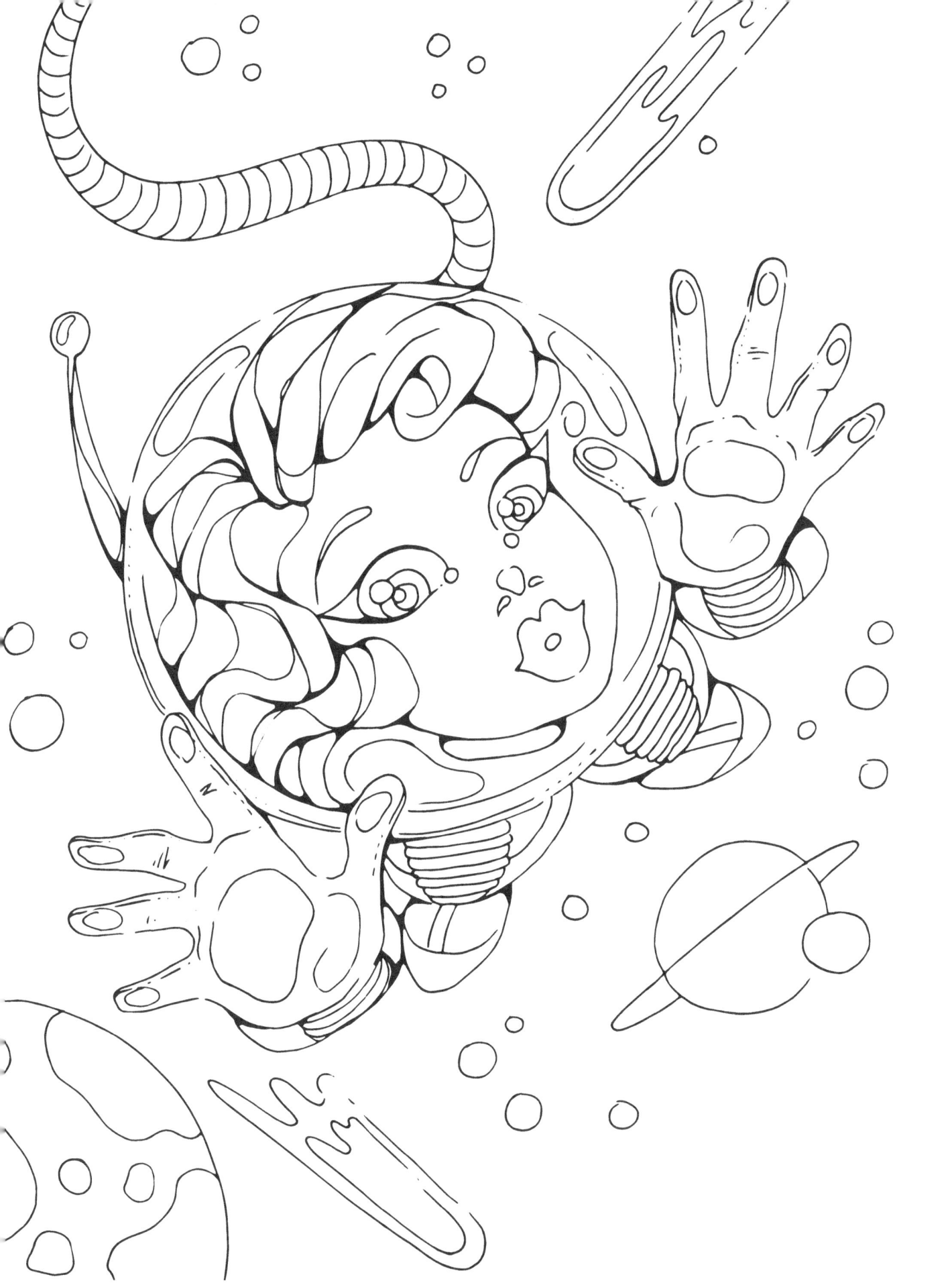

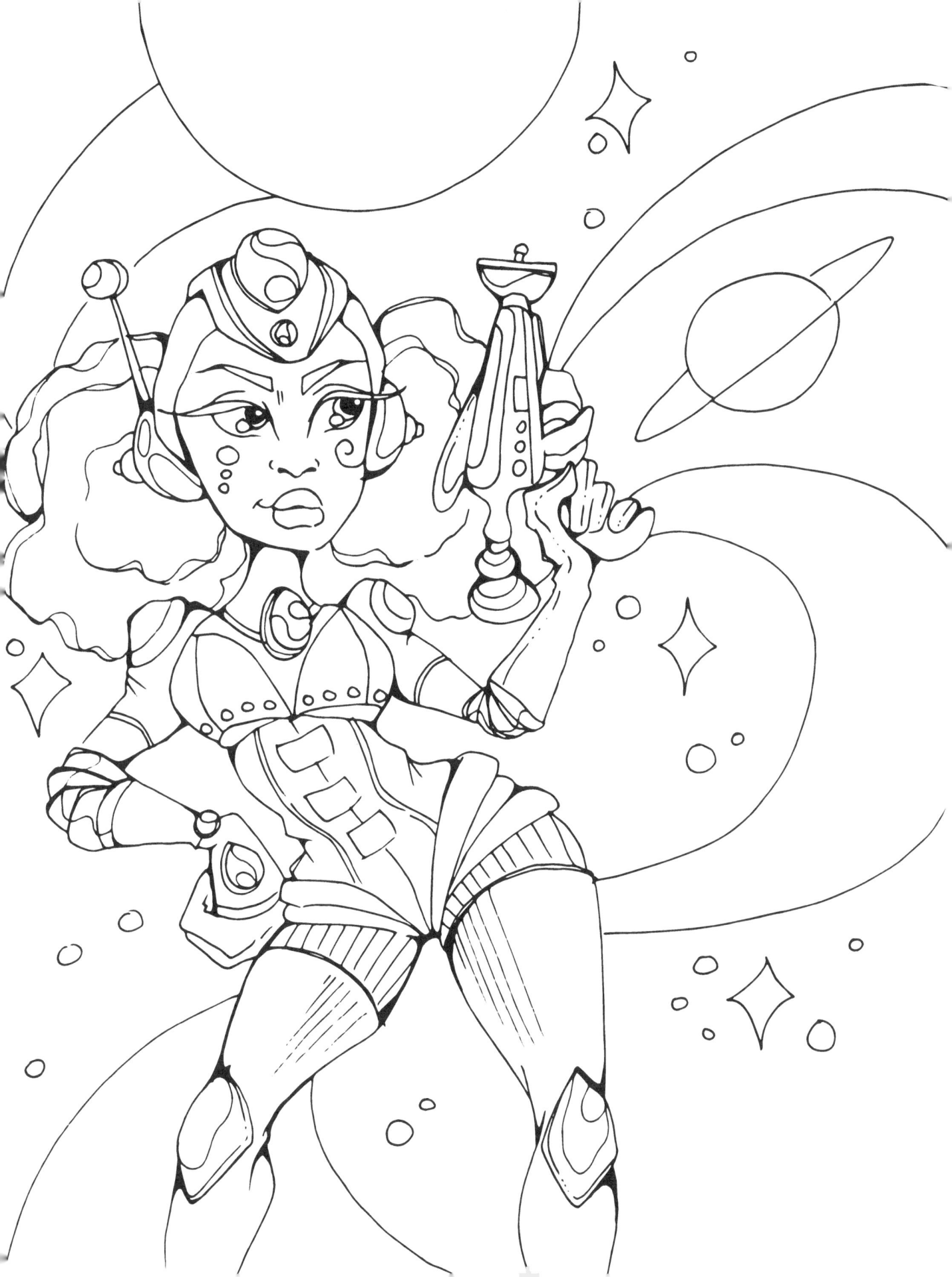

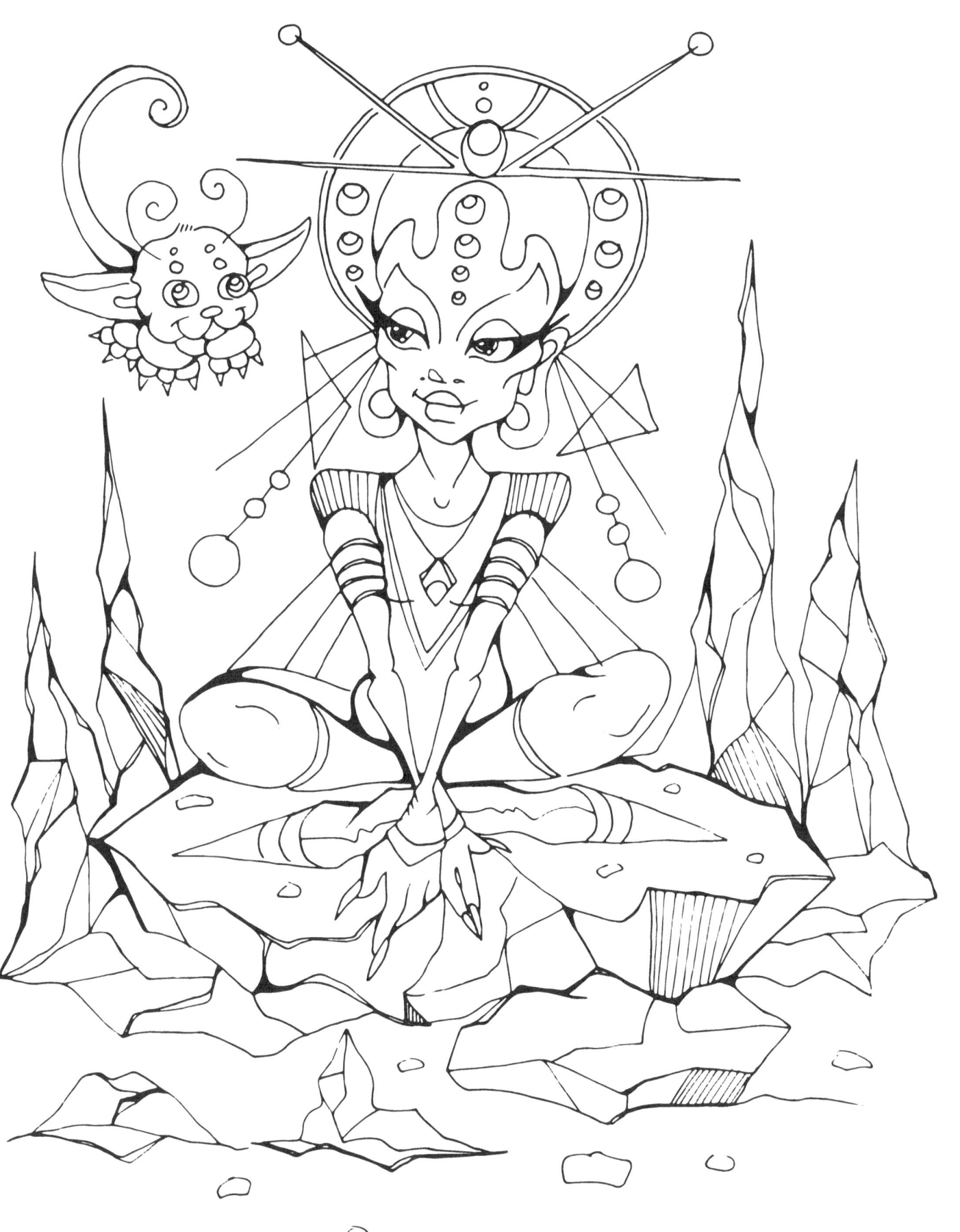

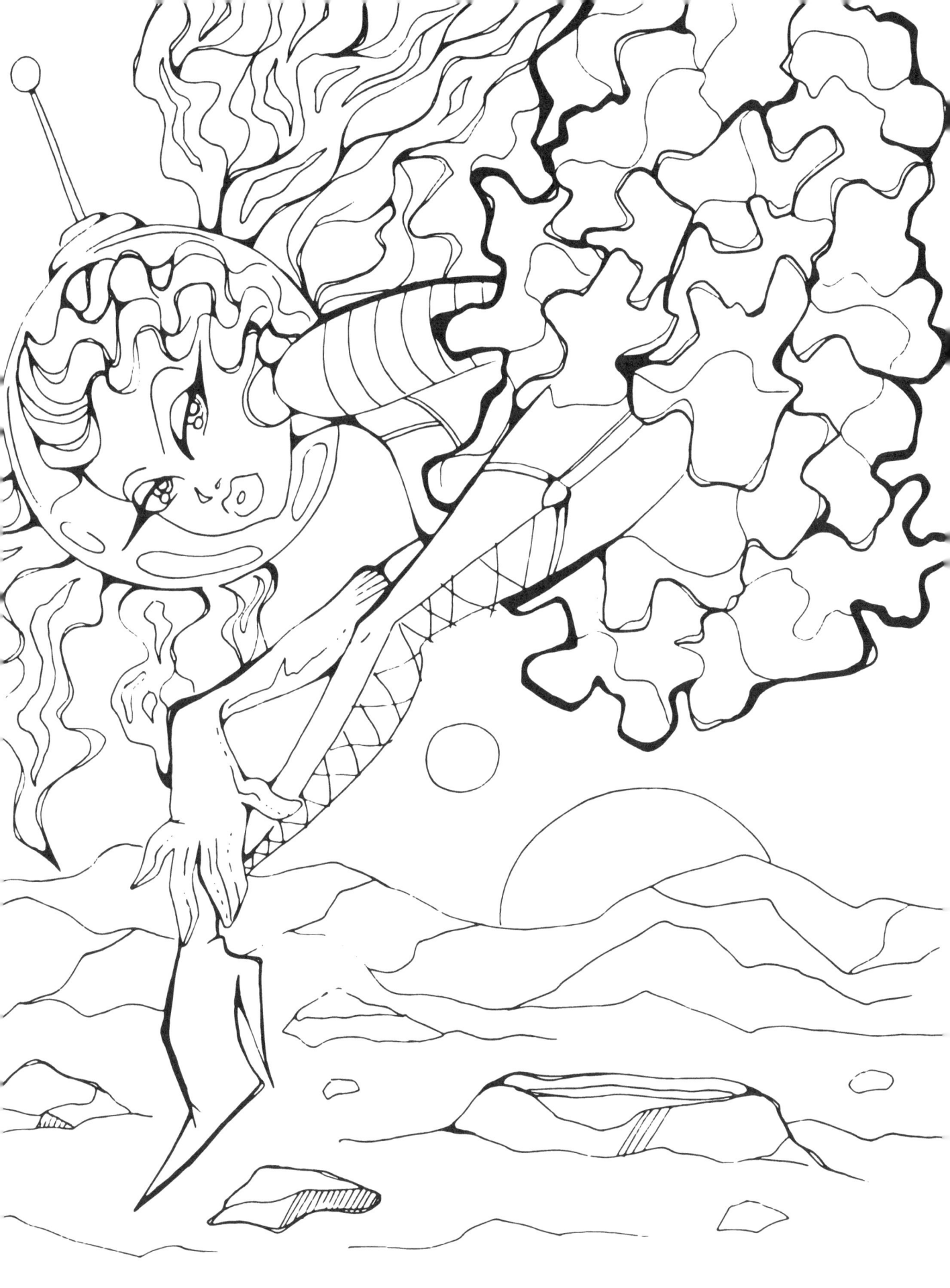

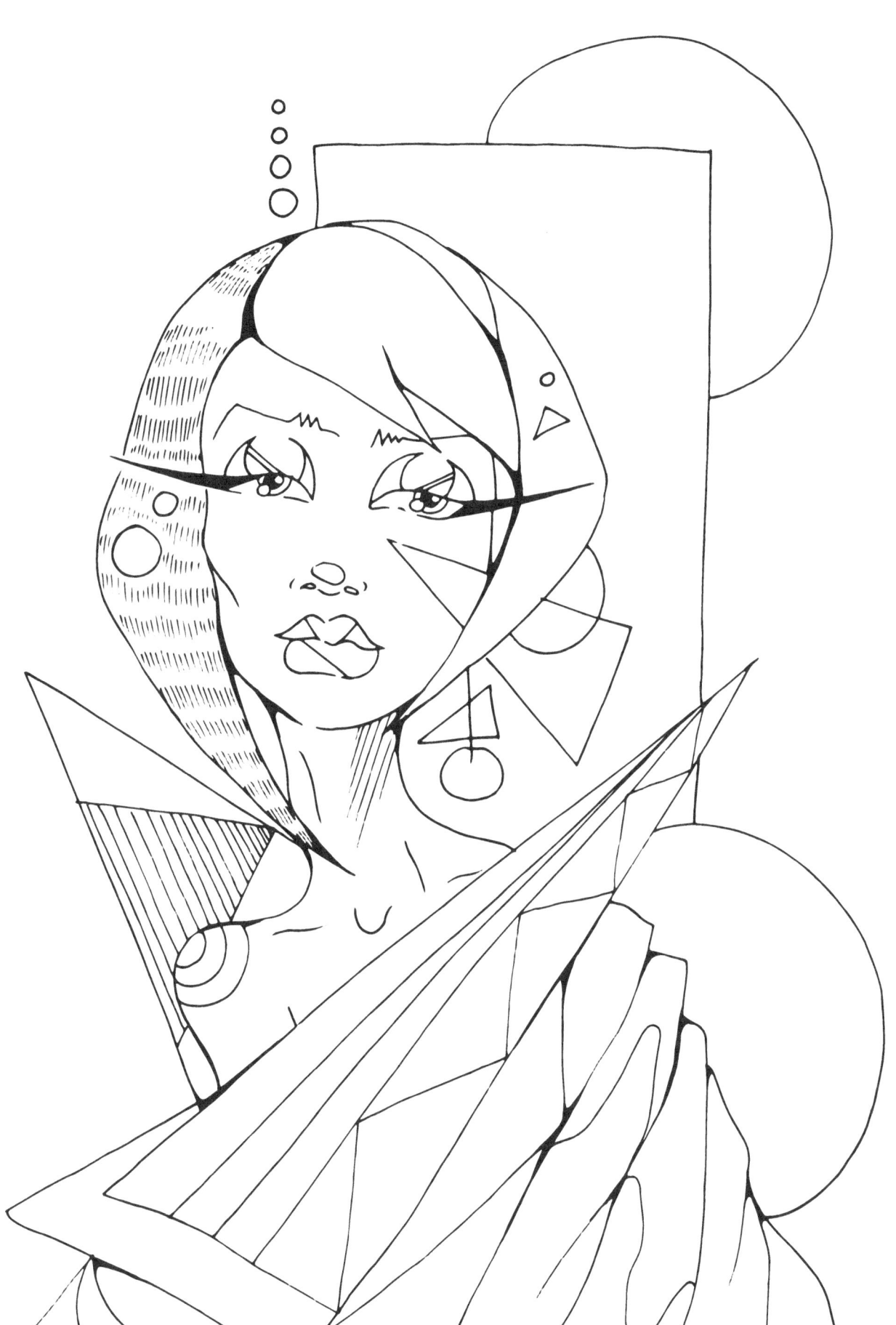

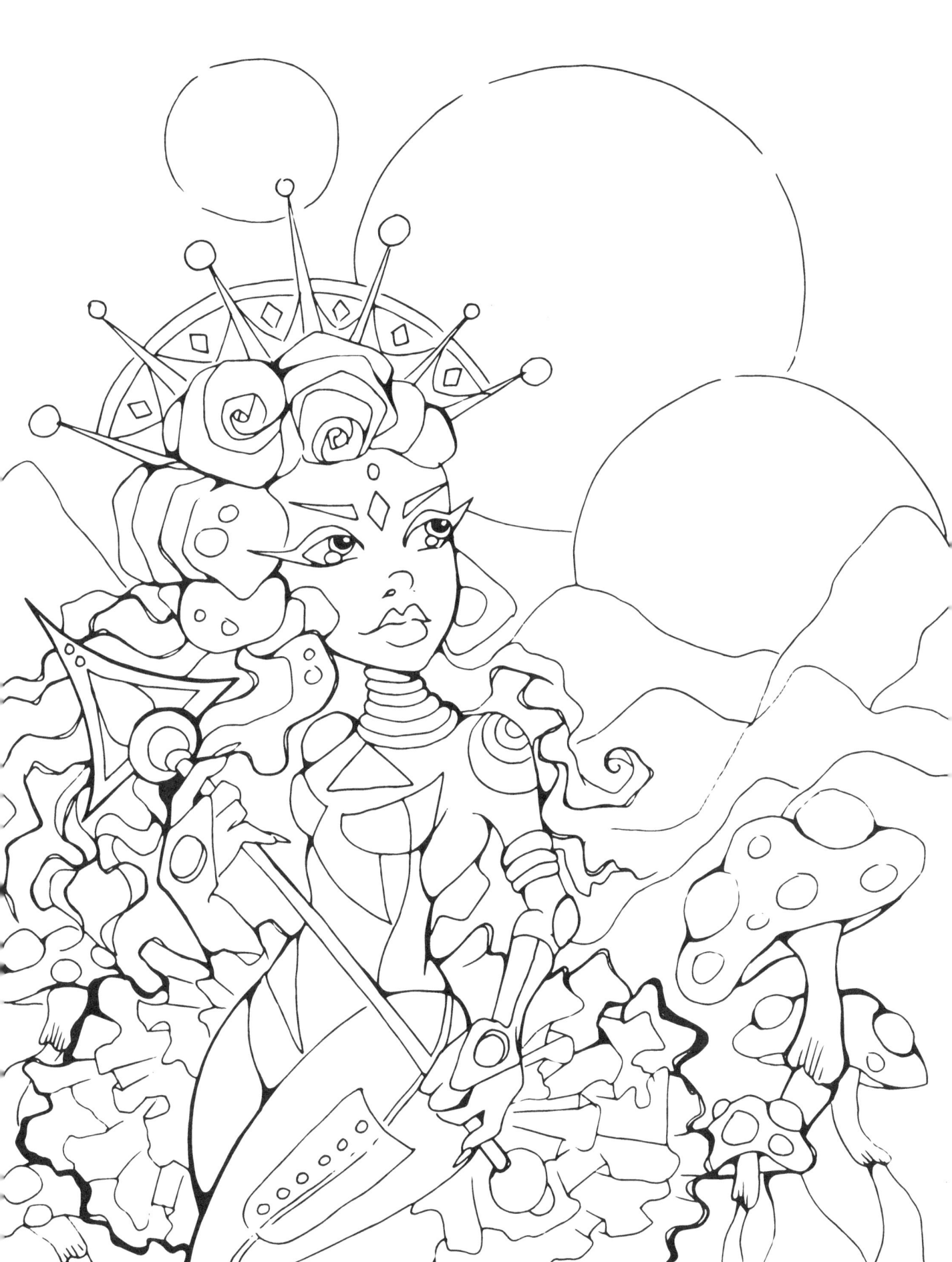

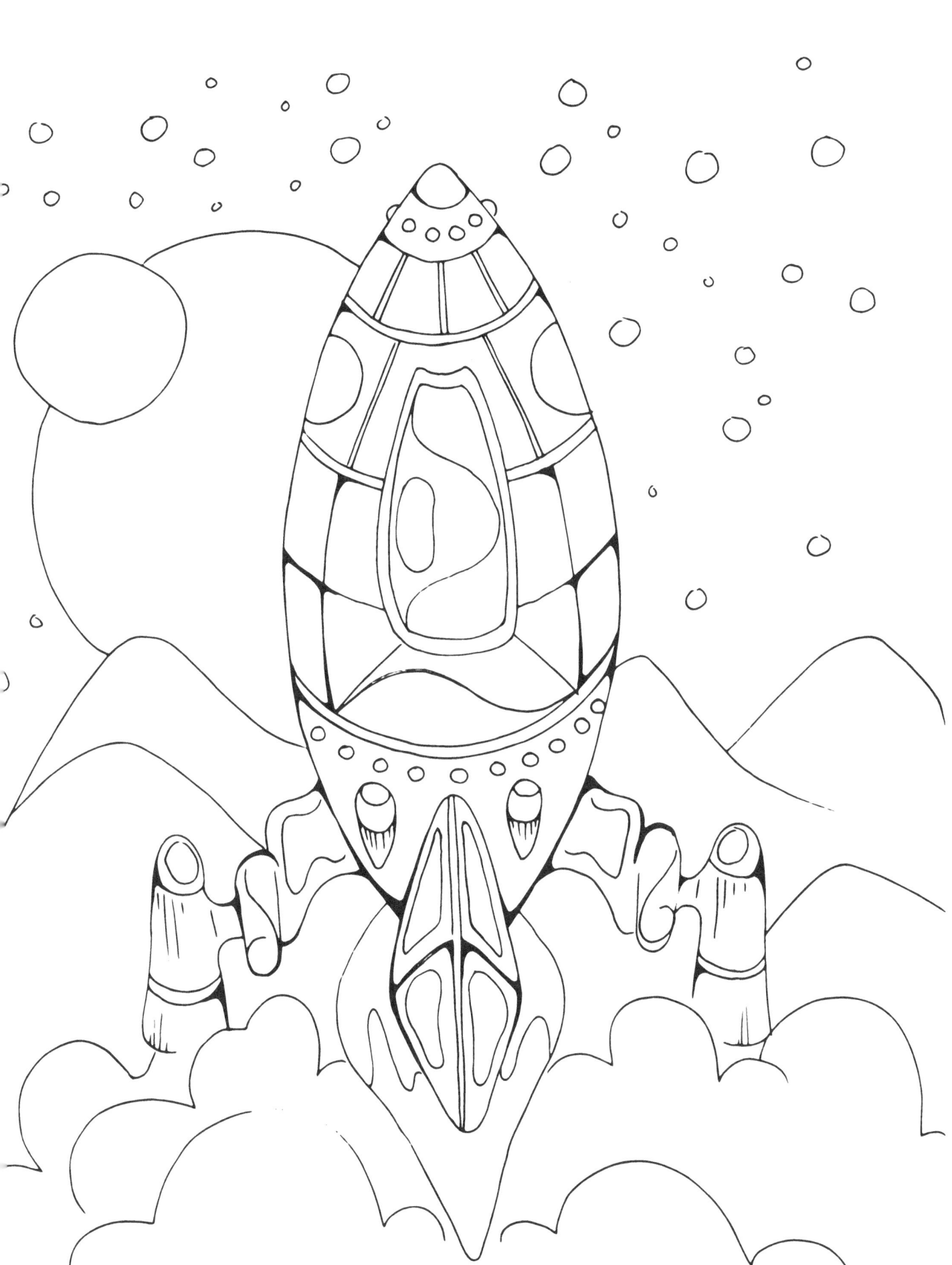

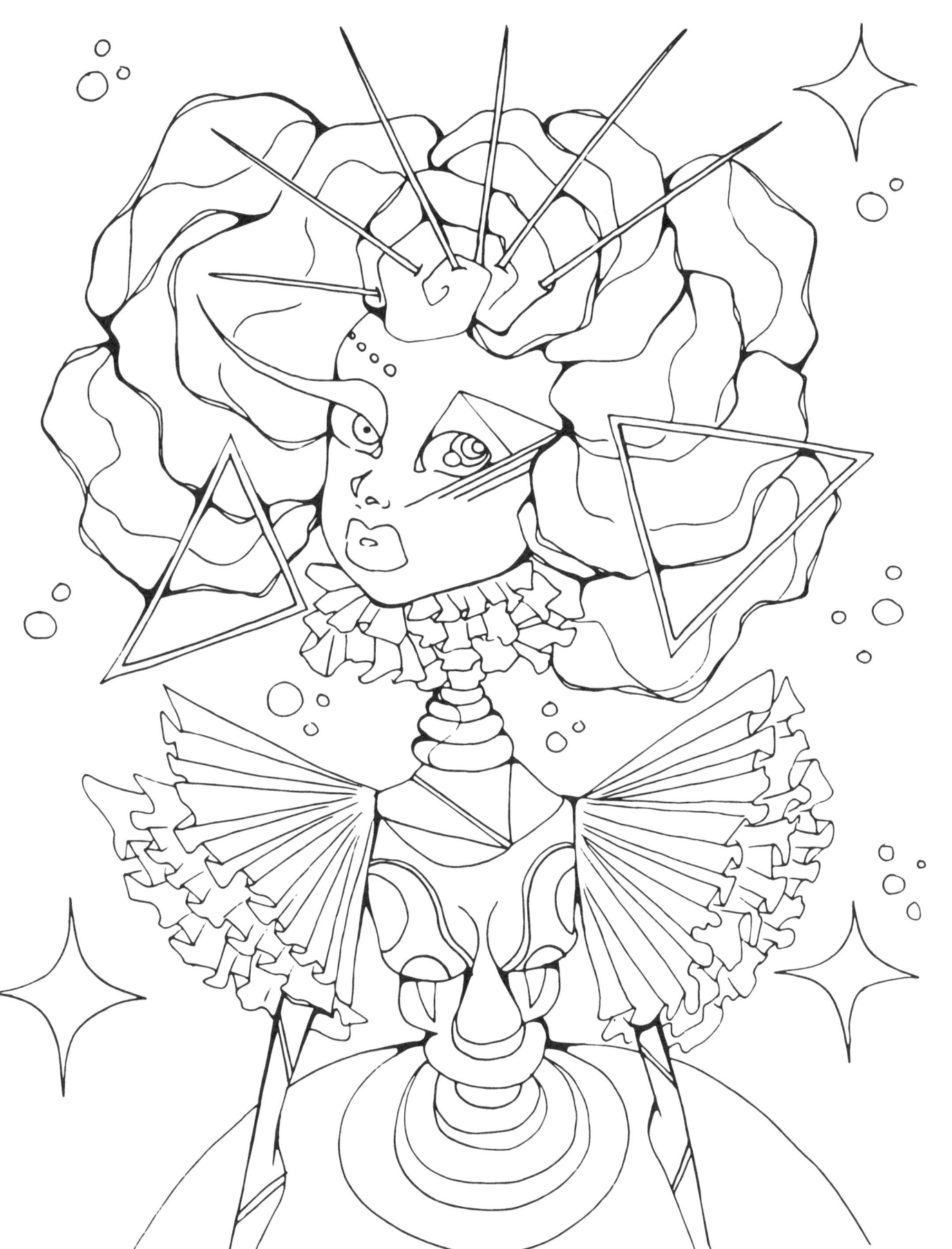

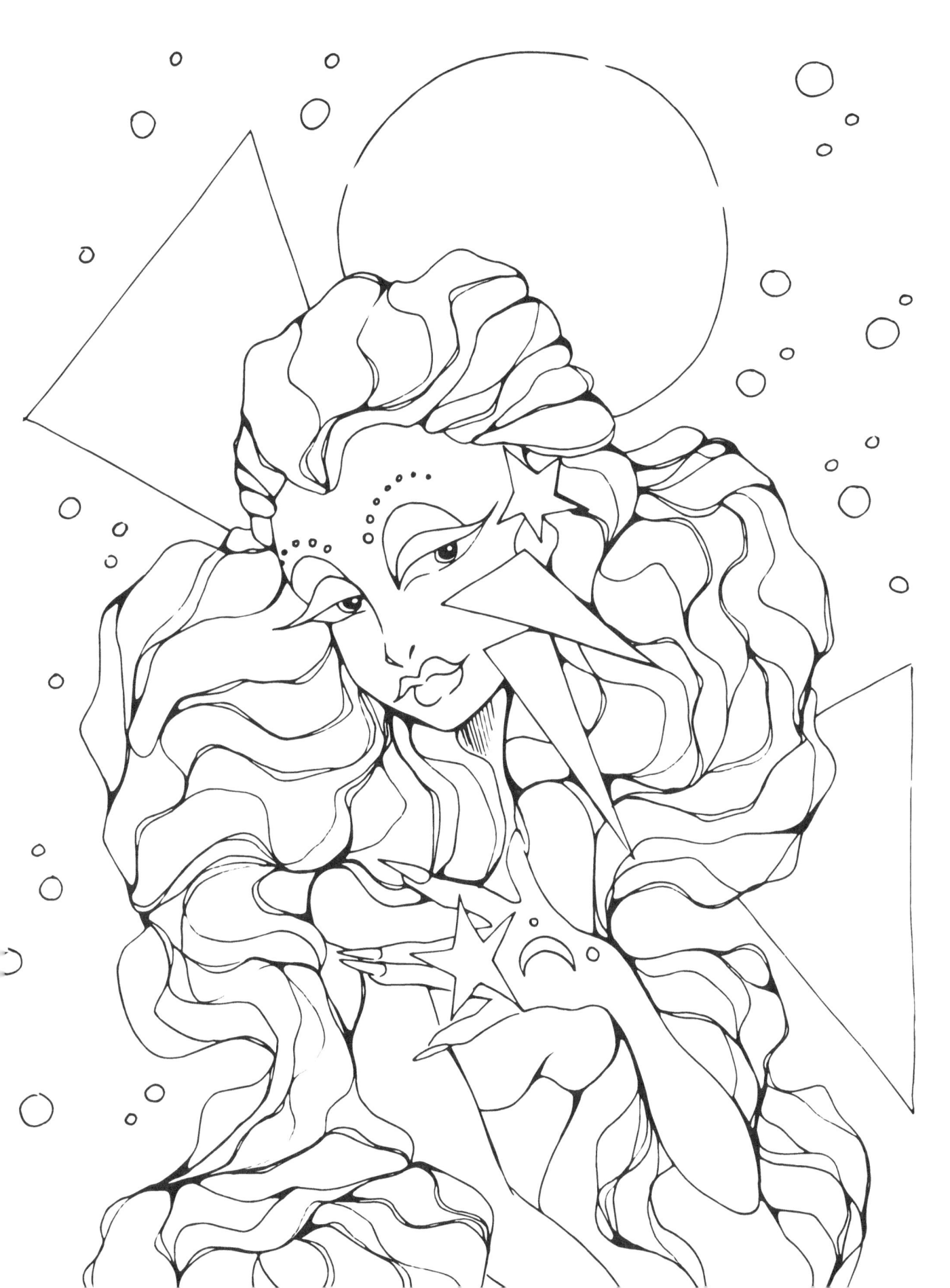

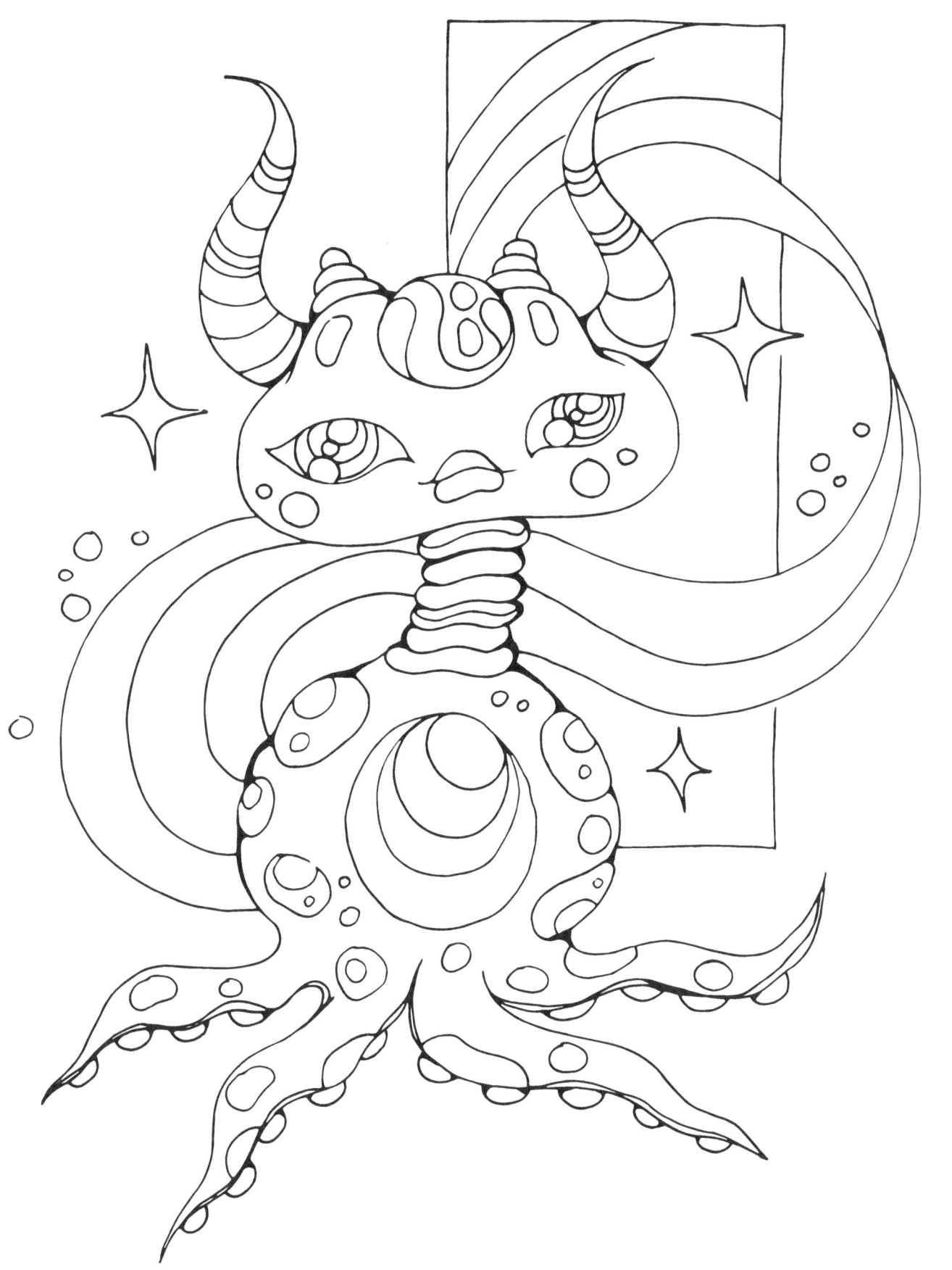

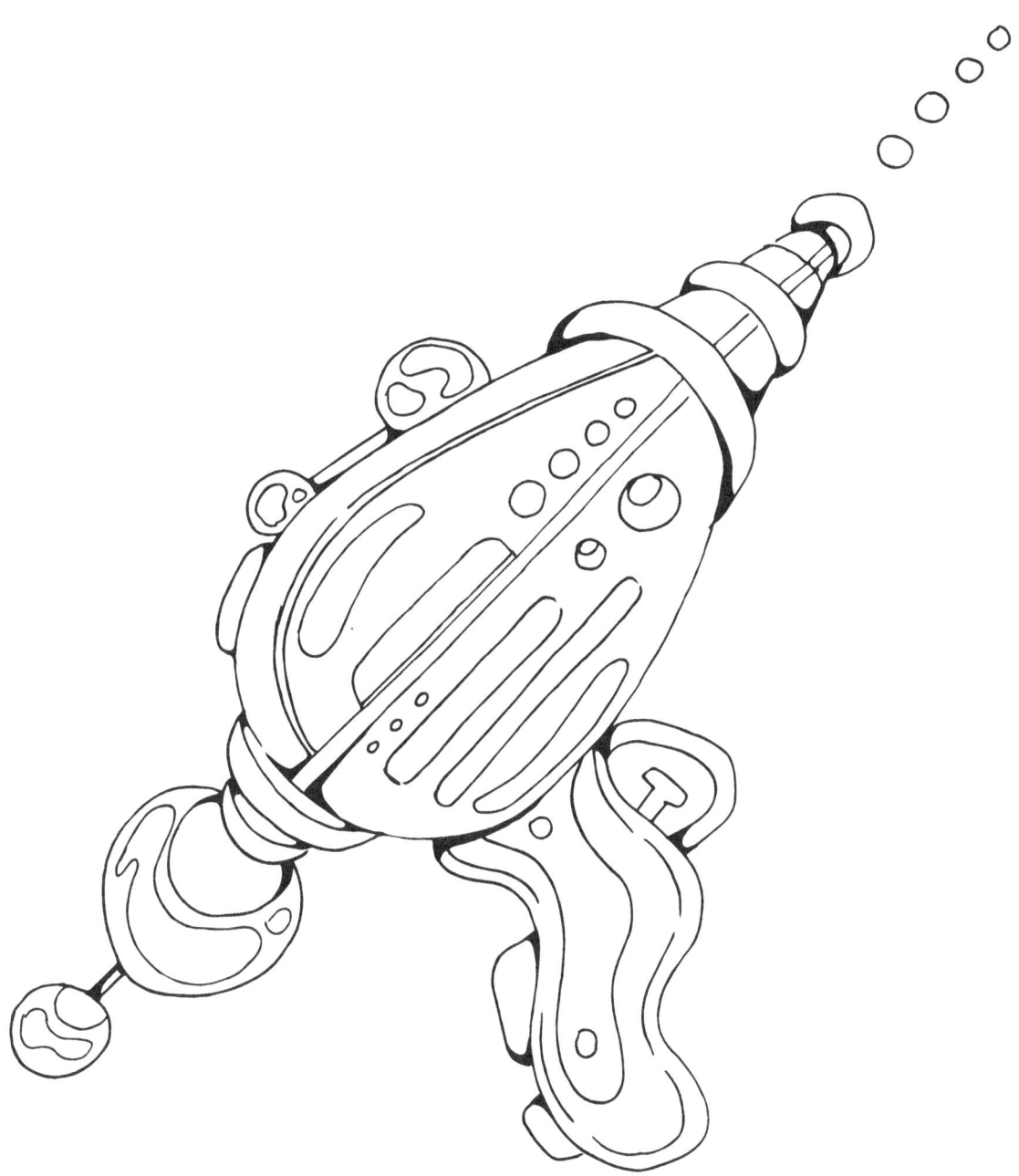

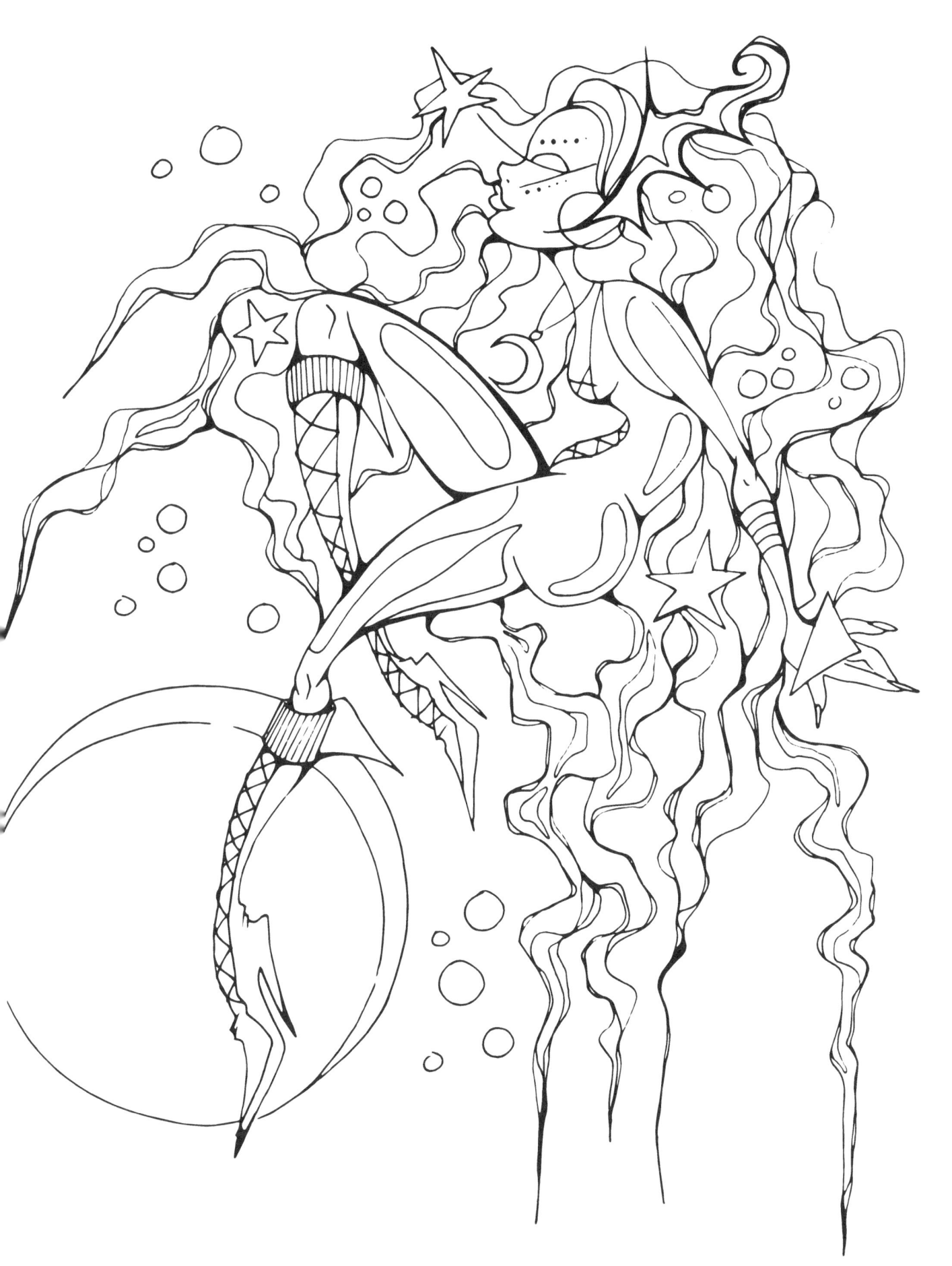

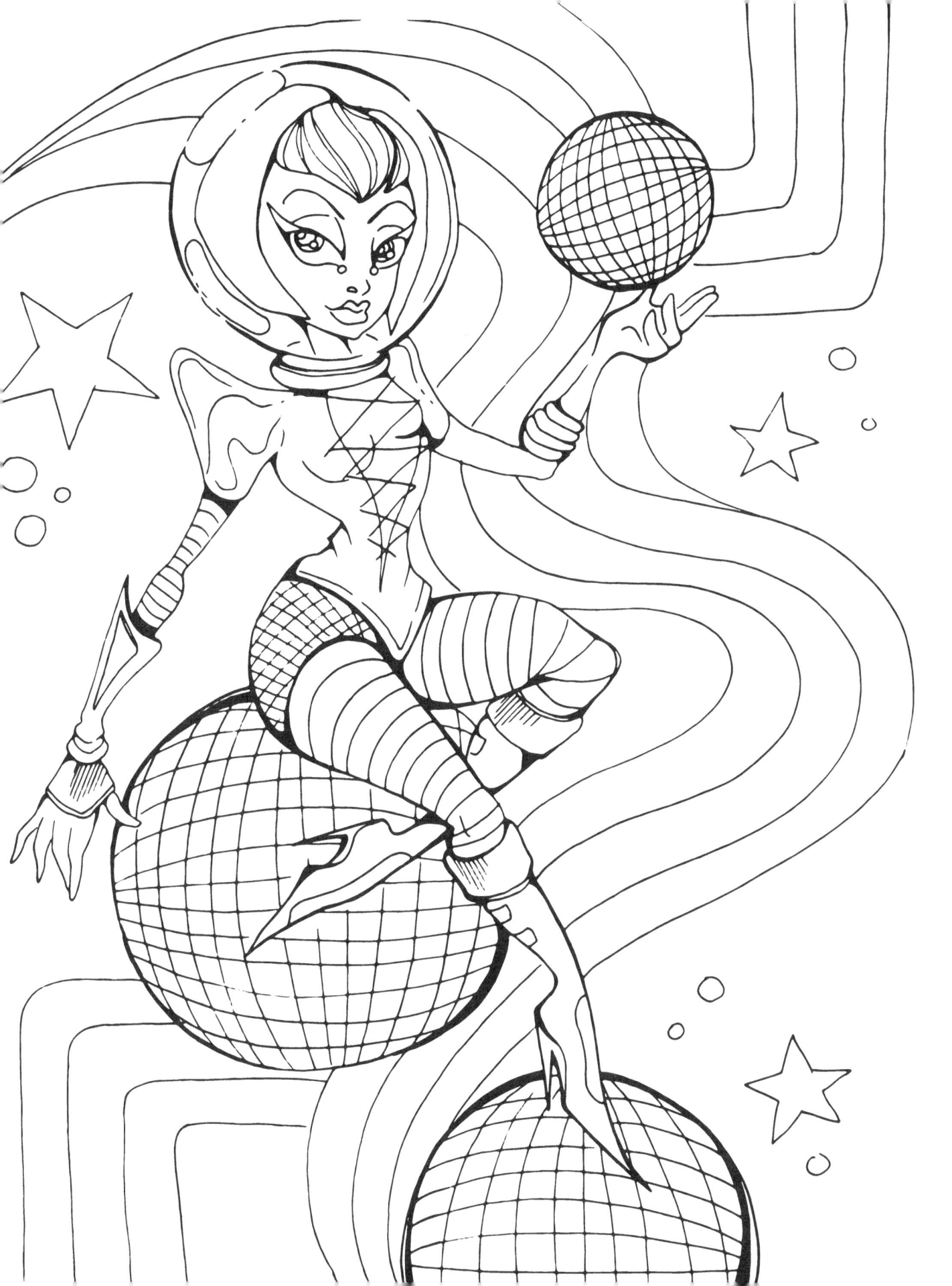

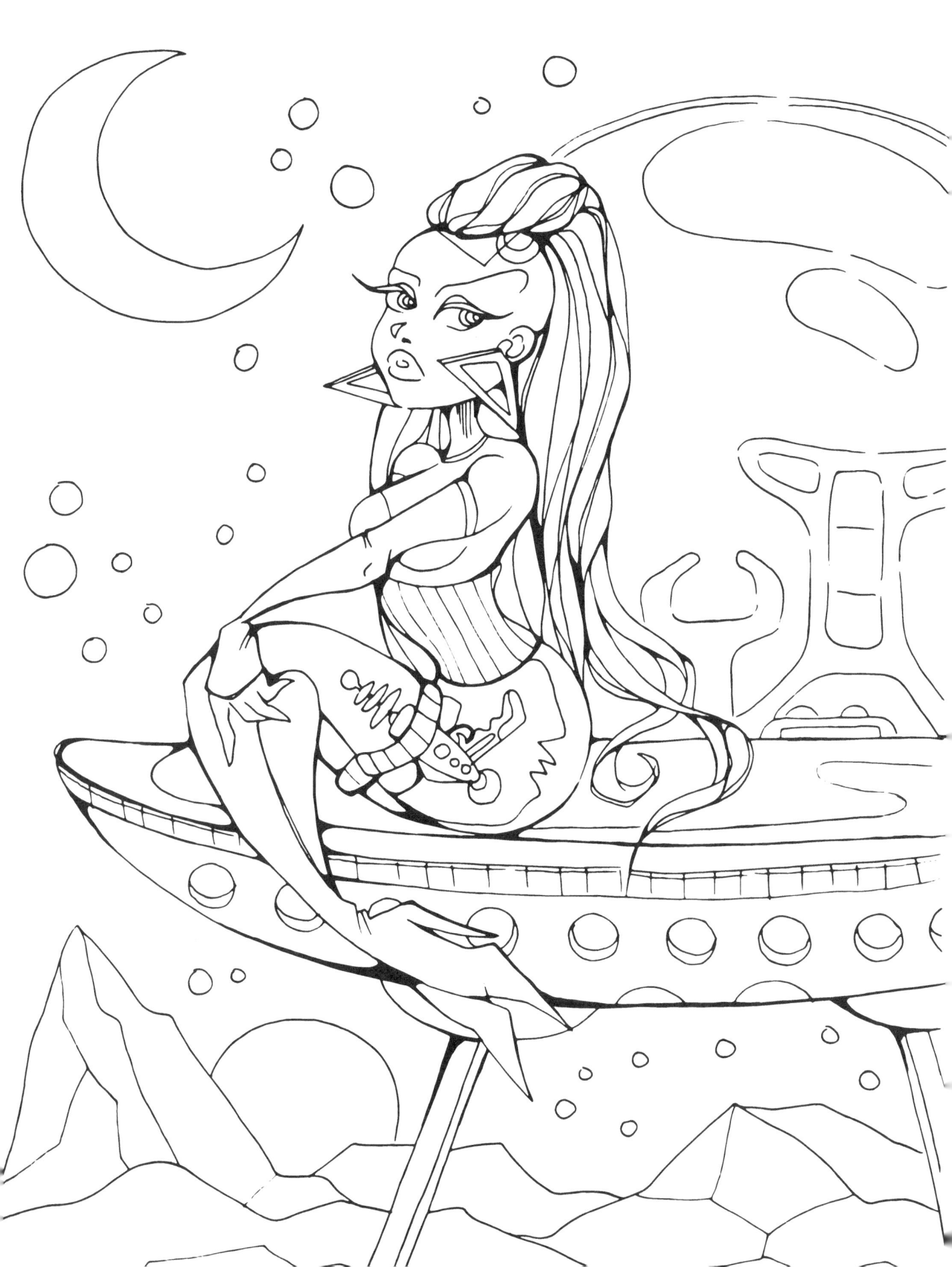

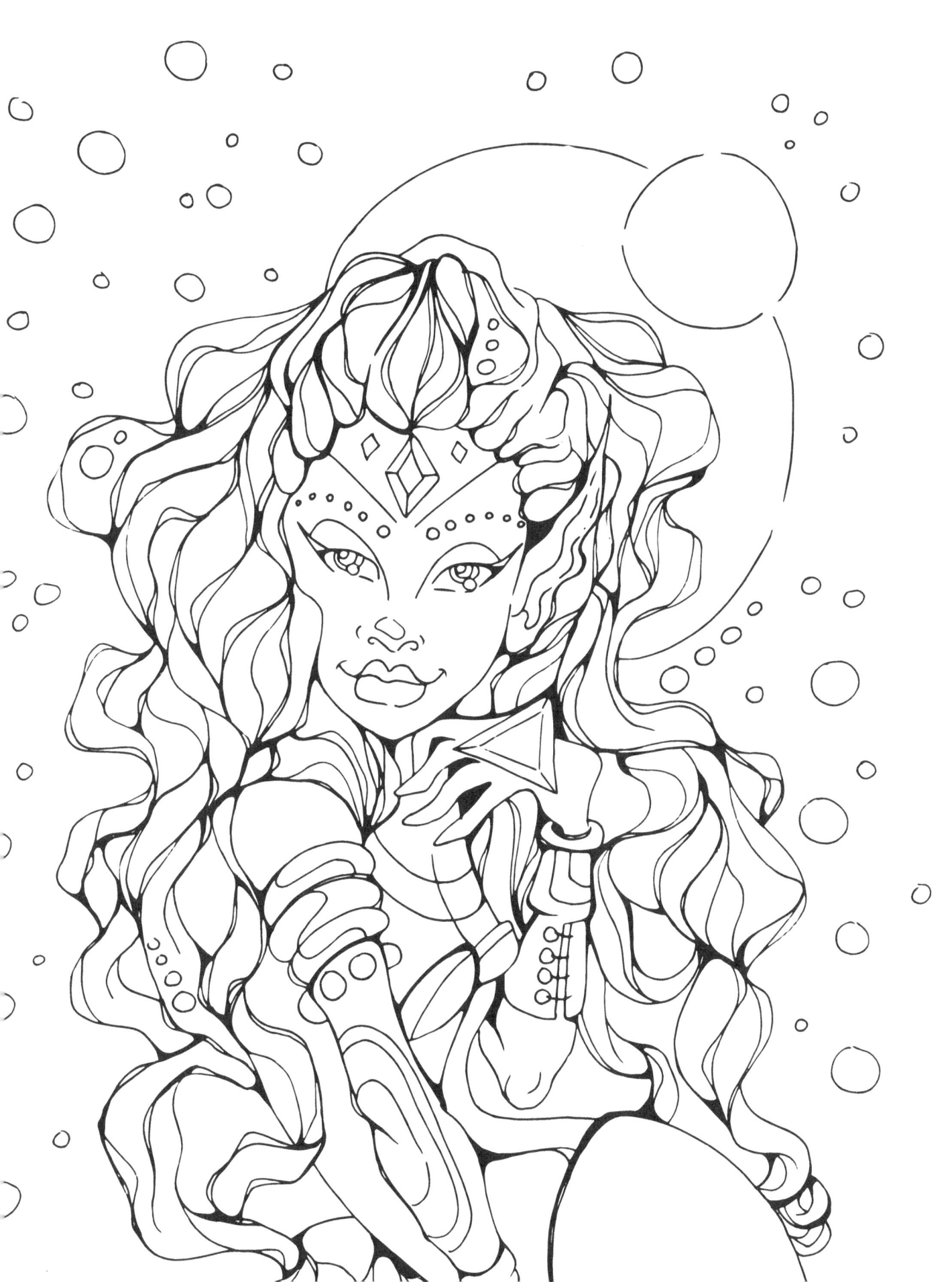

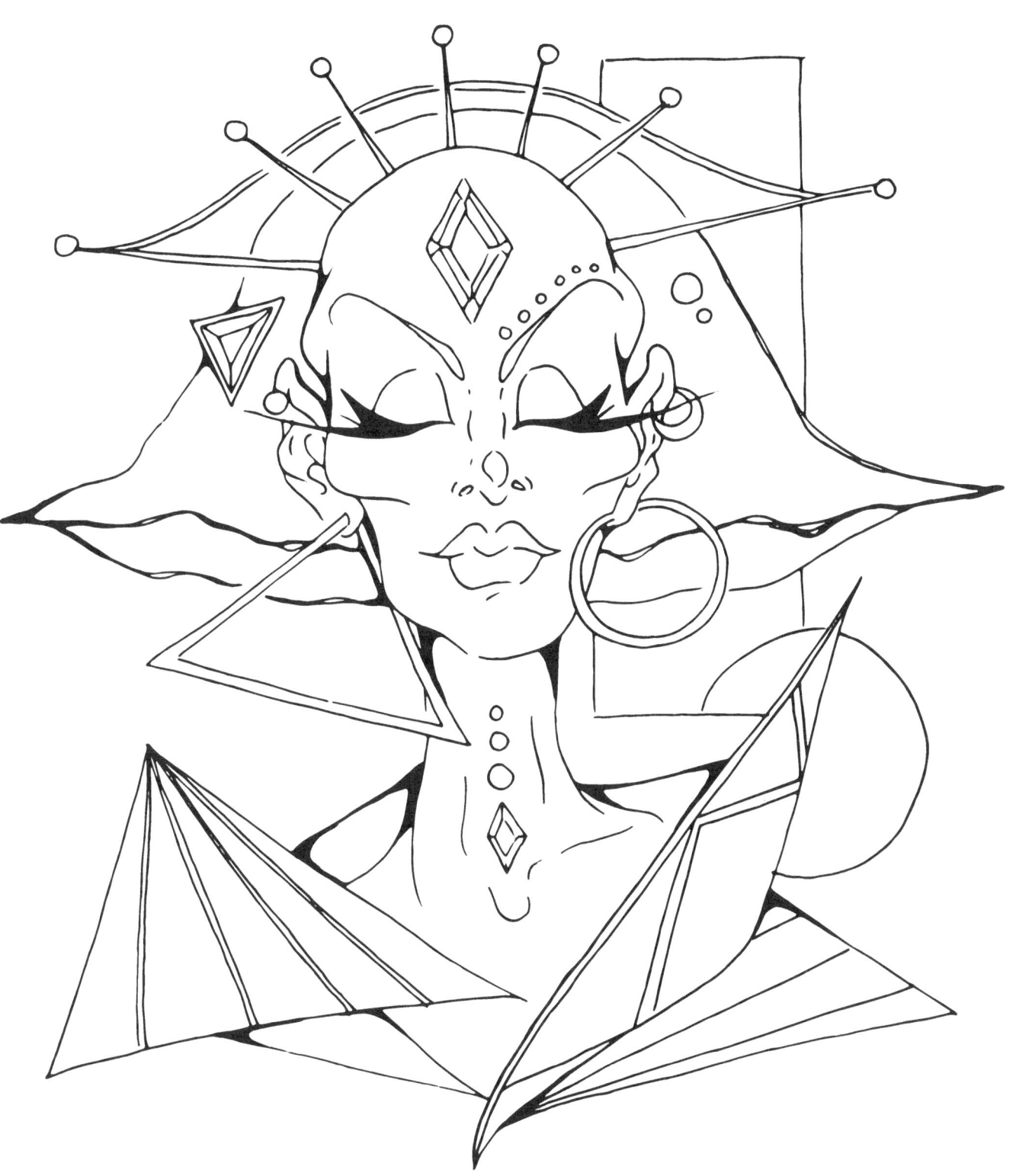

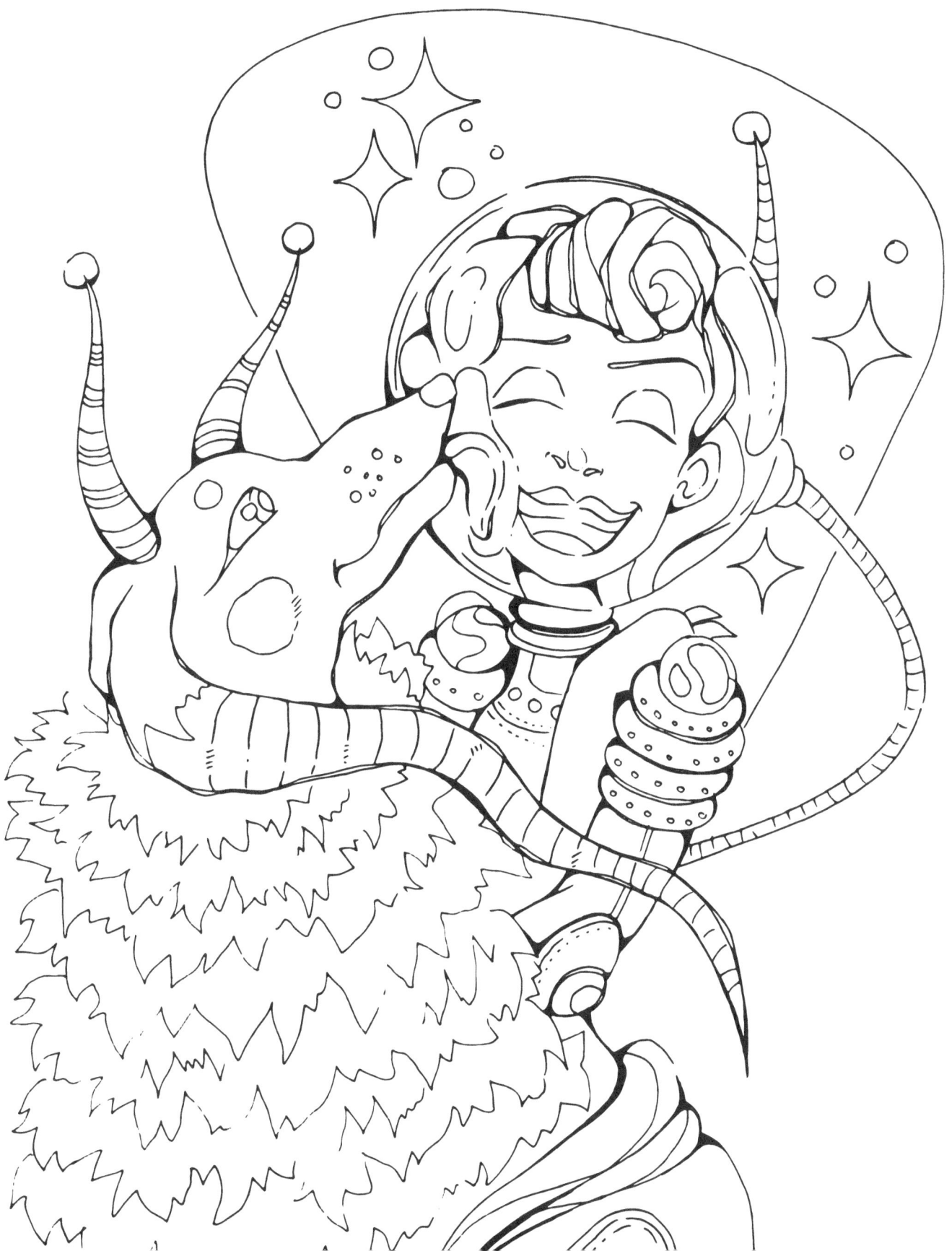

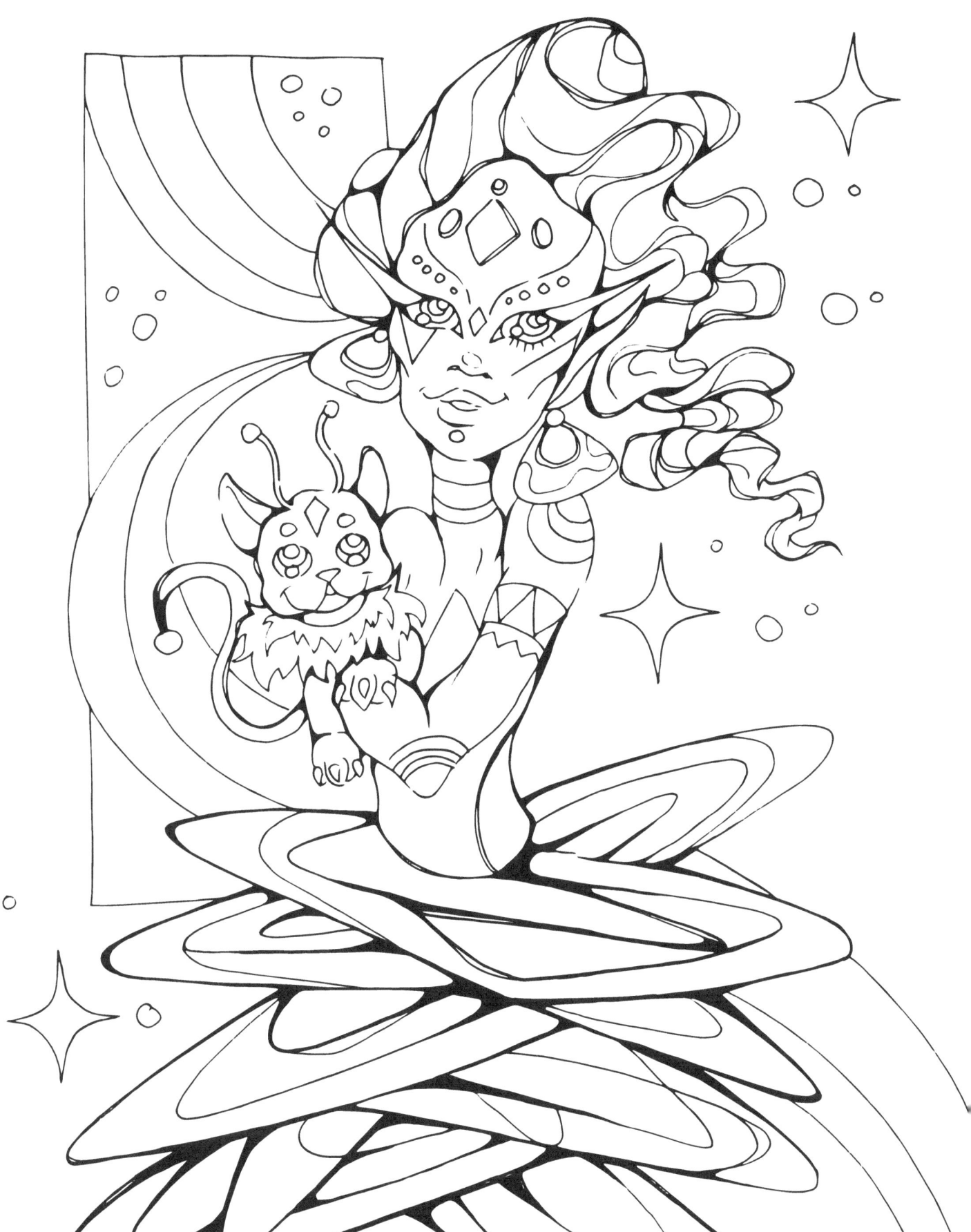

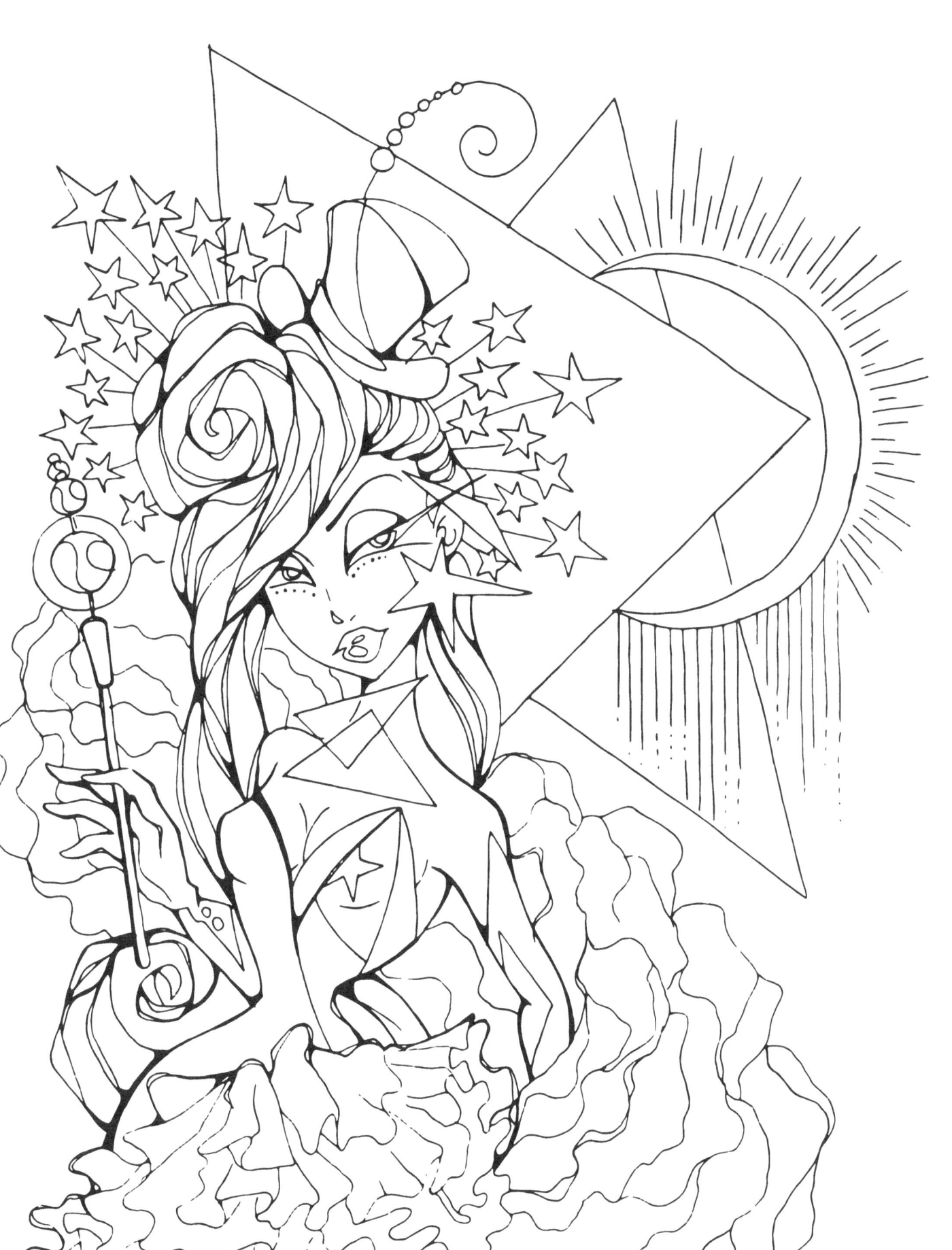

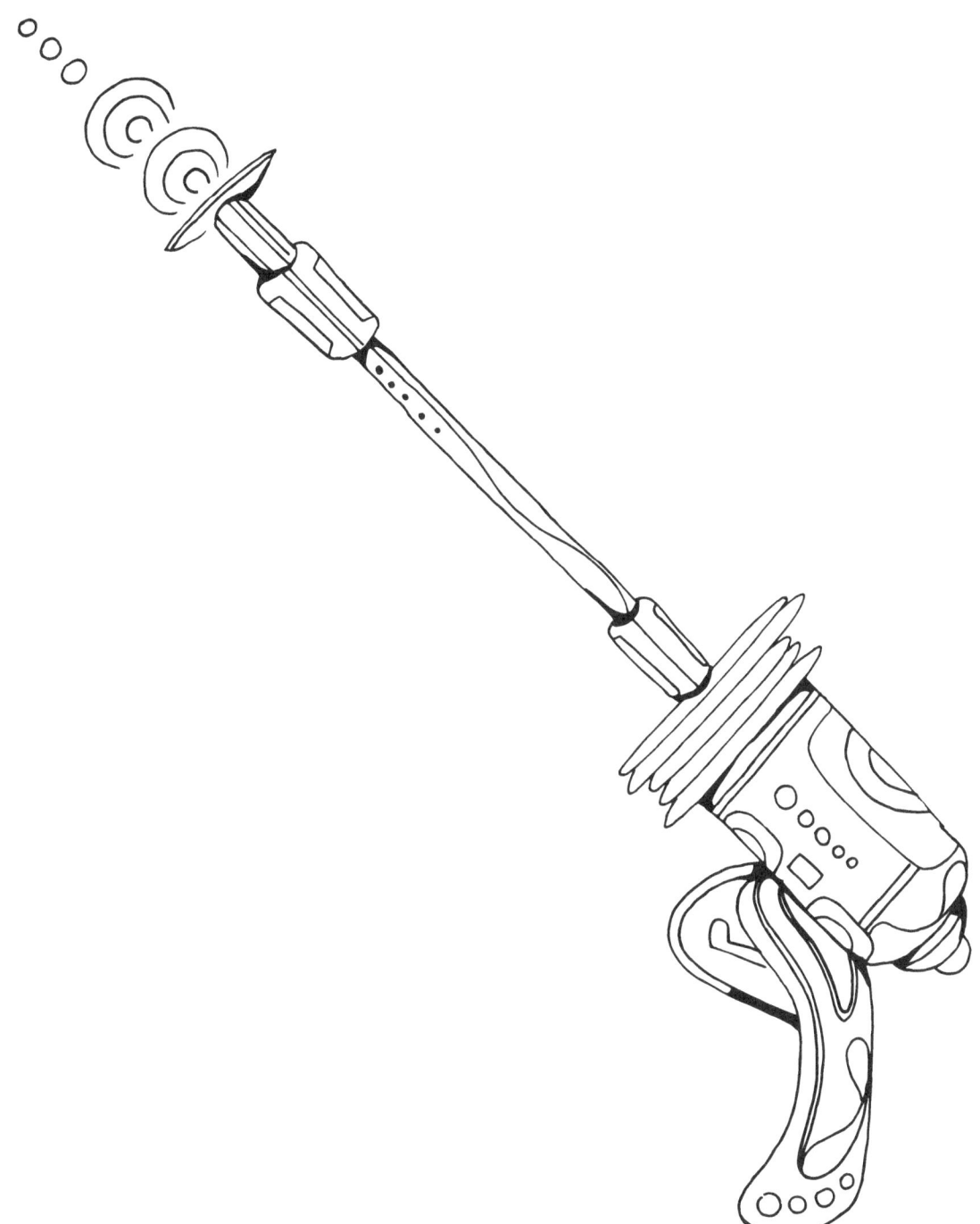

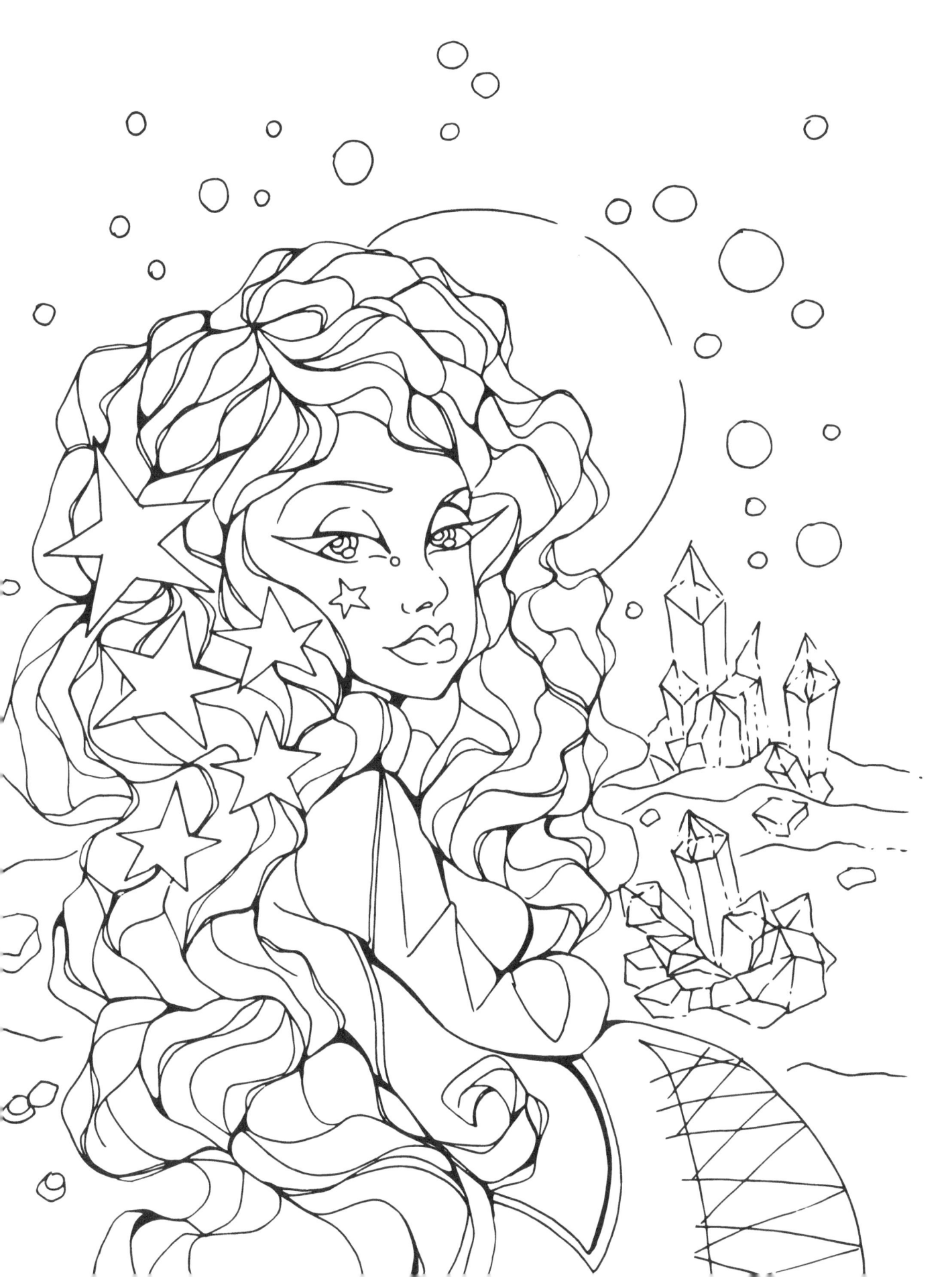

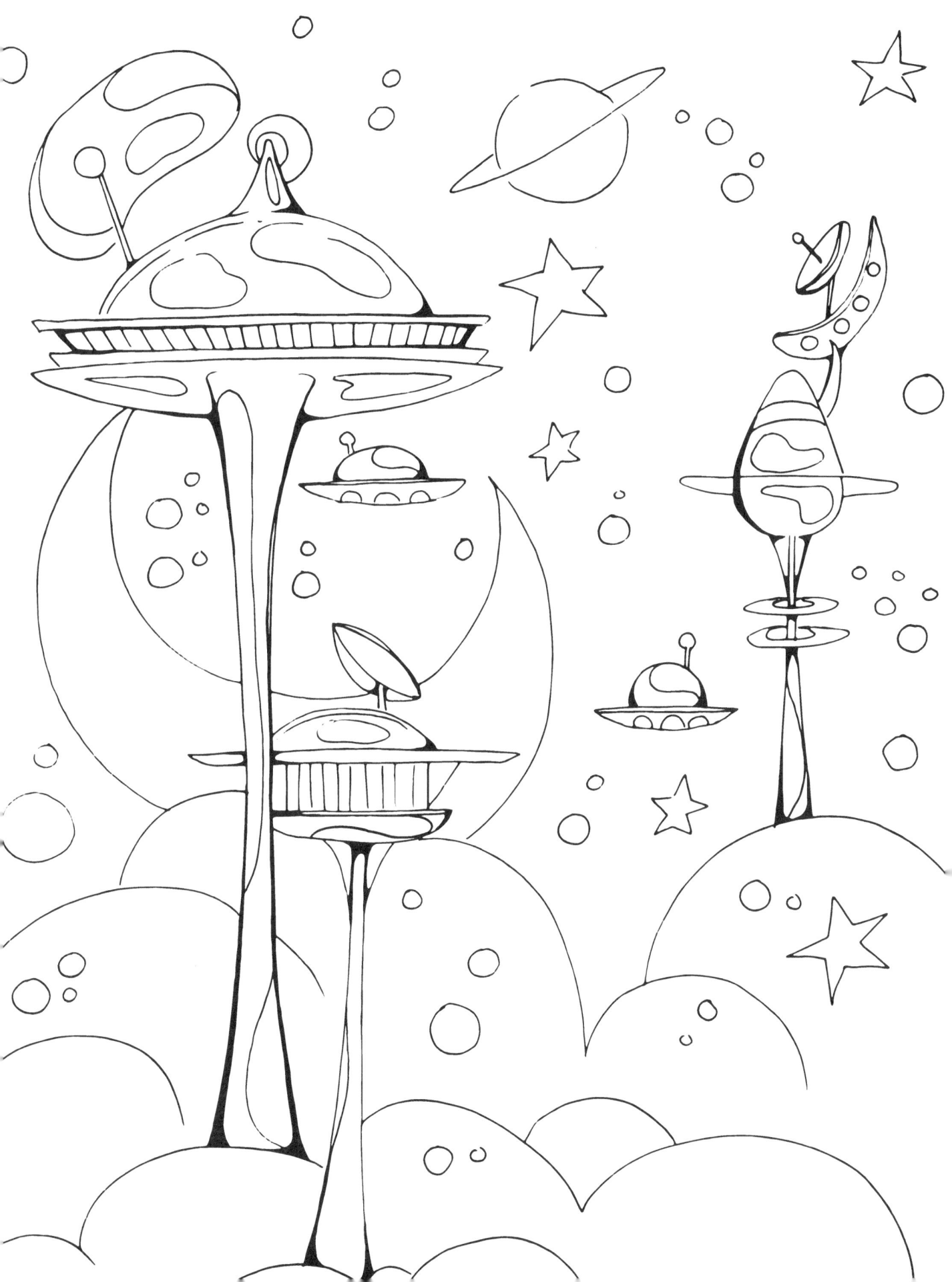

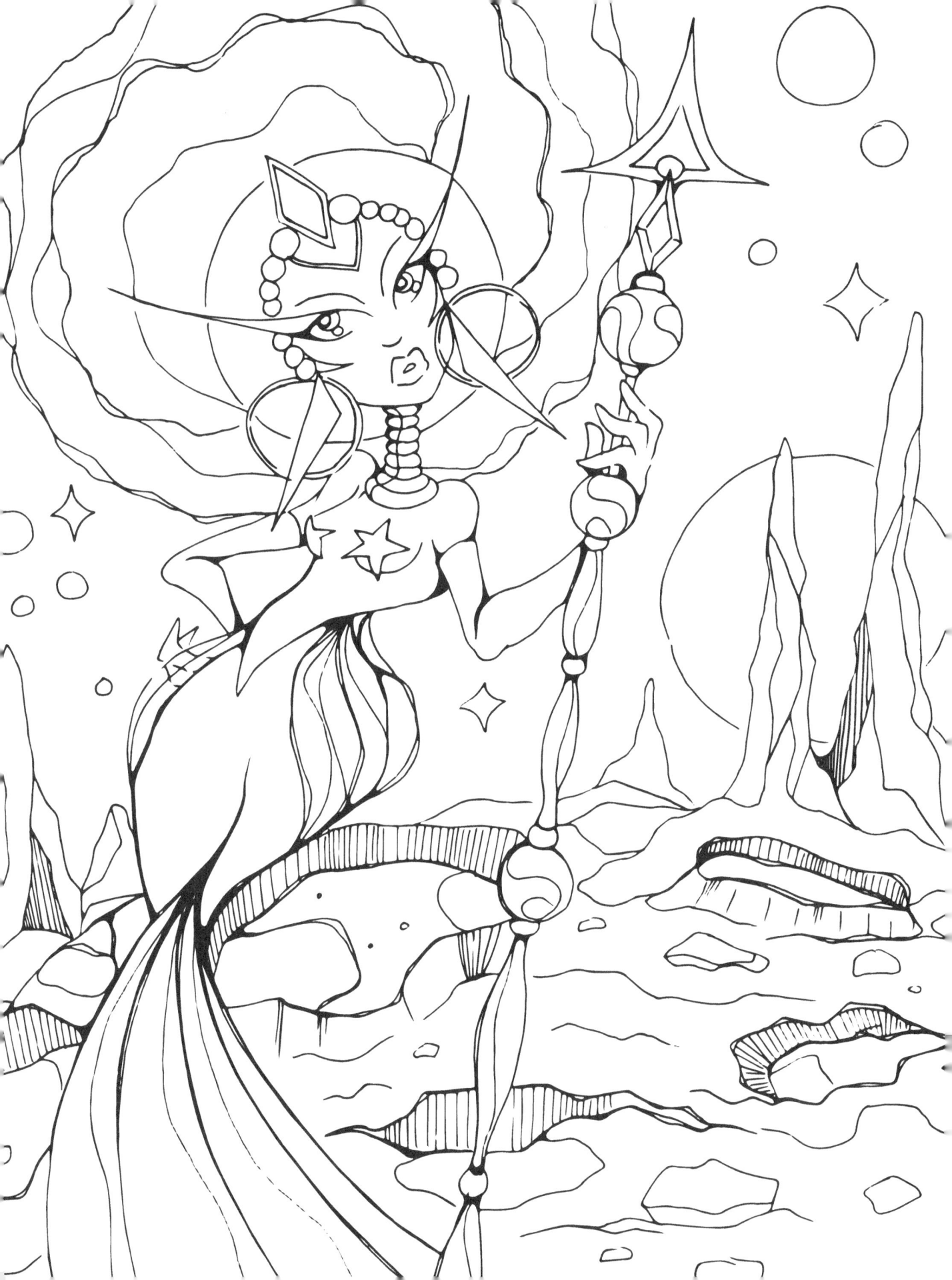

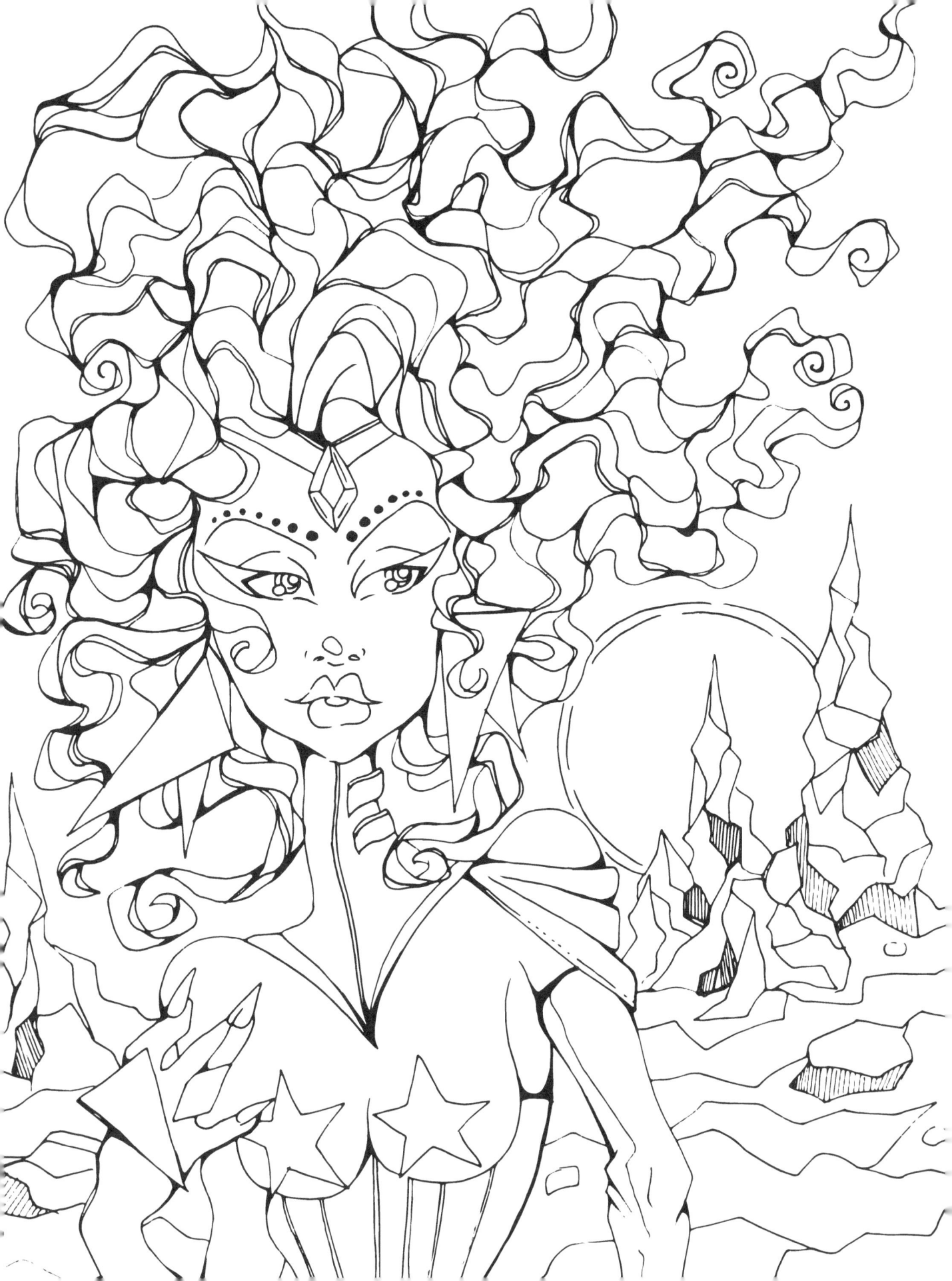

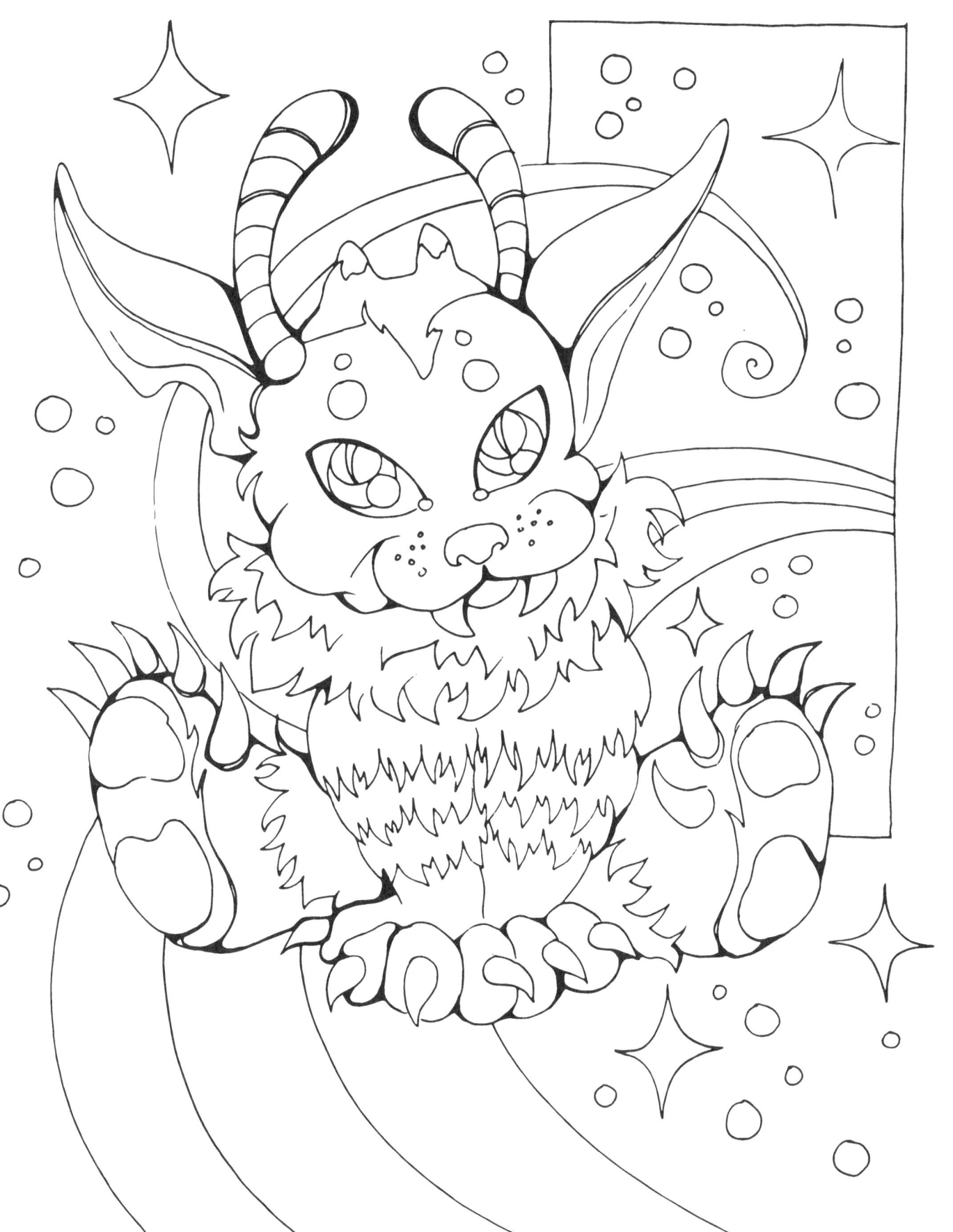

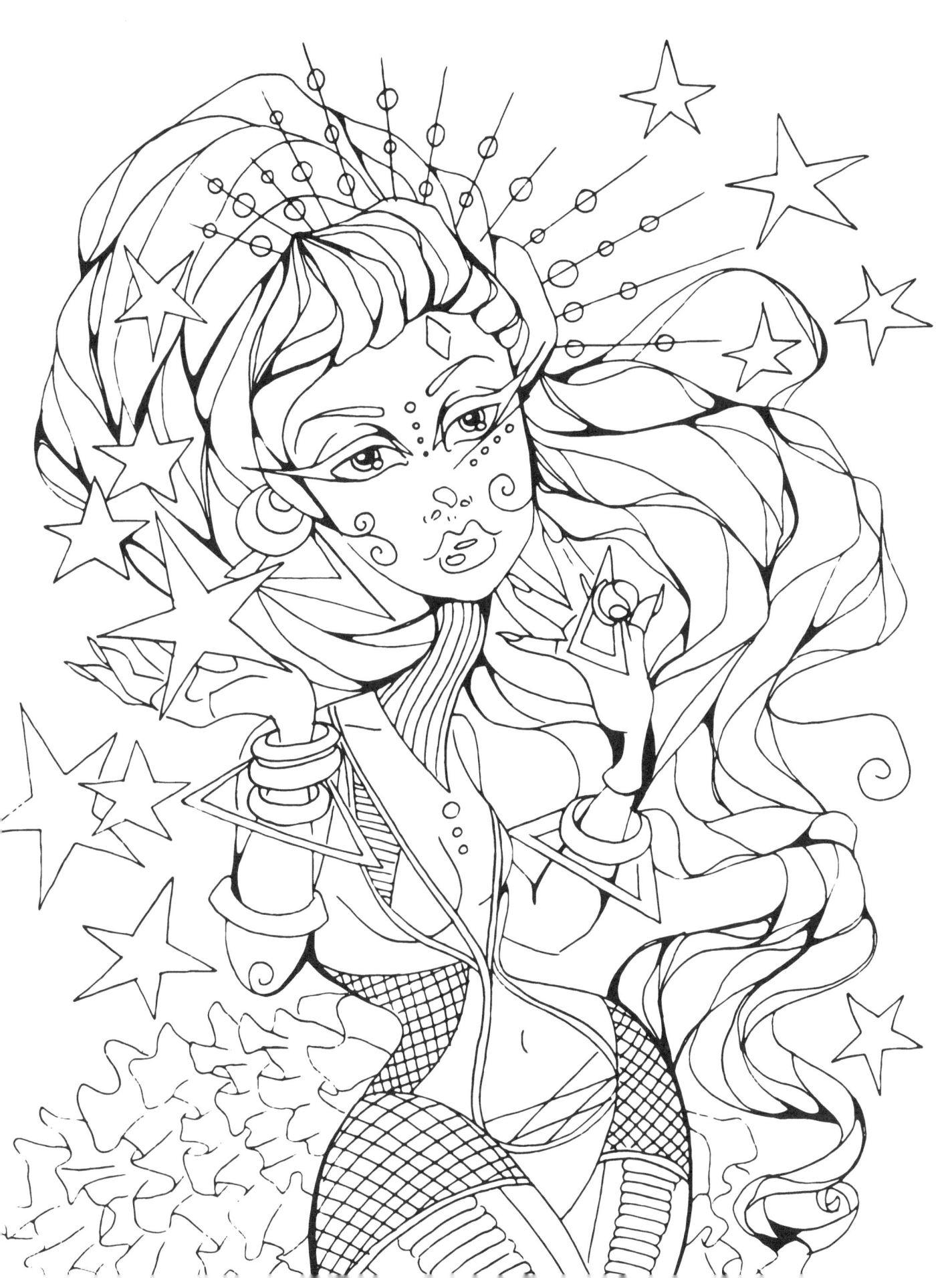

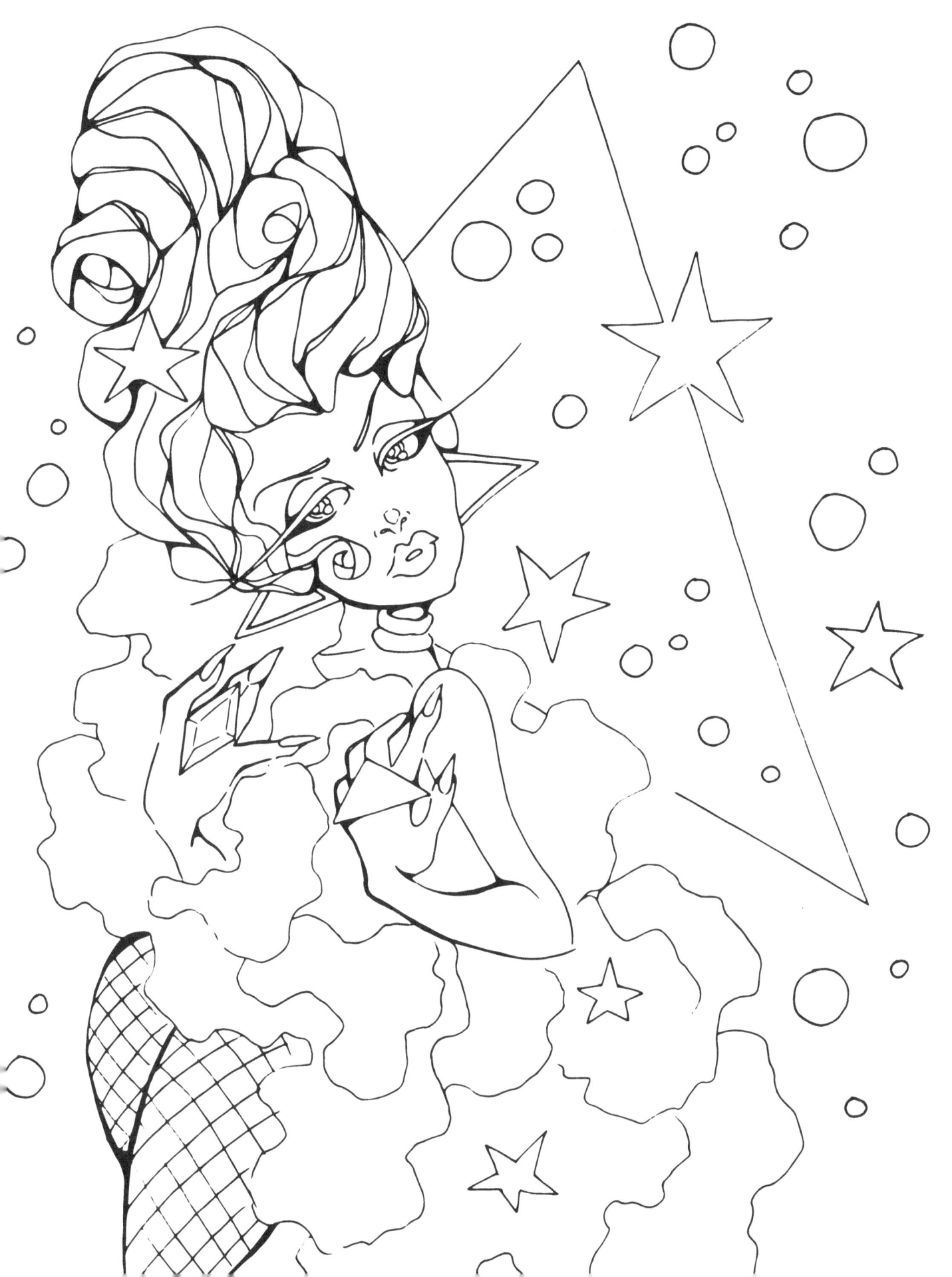

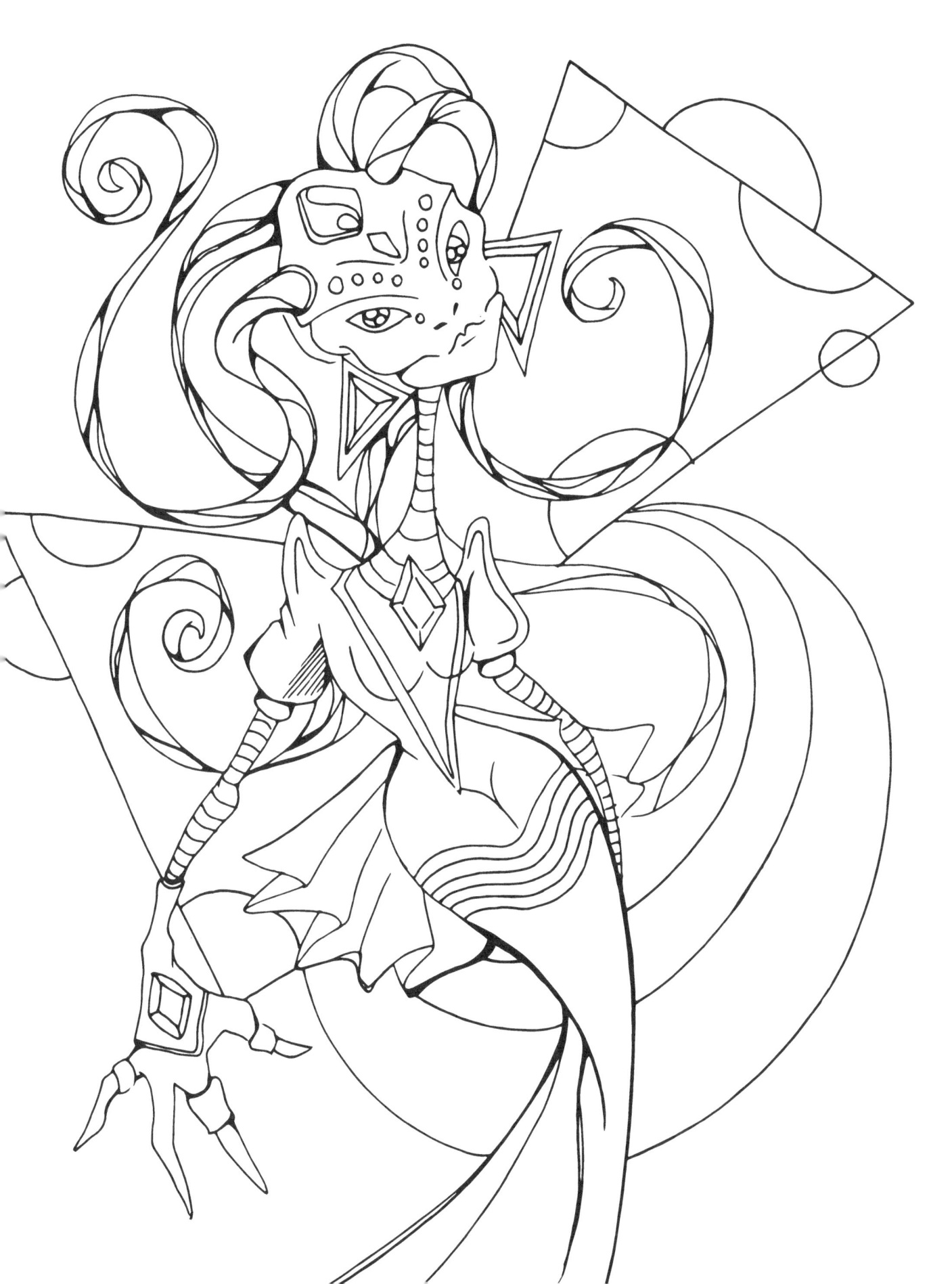

TEST YOUR SUPPLIES HERE

AND
HERE

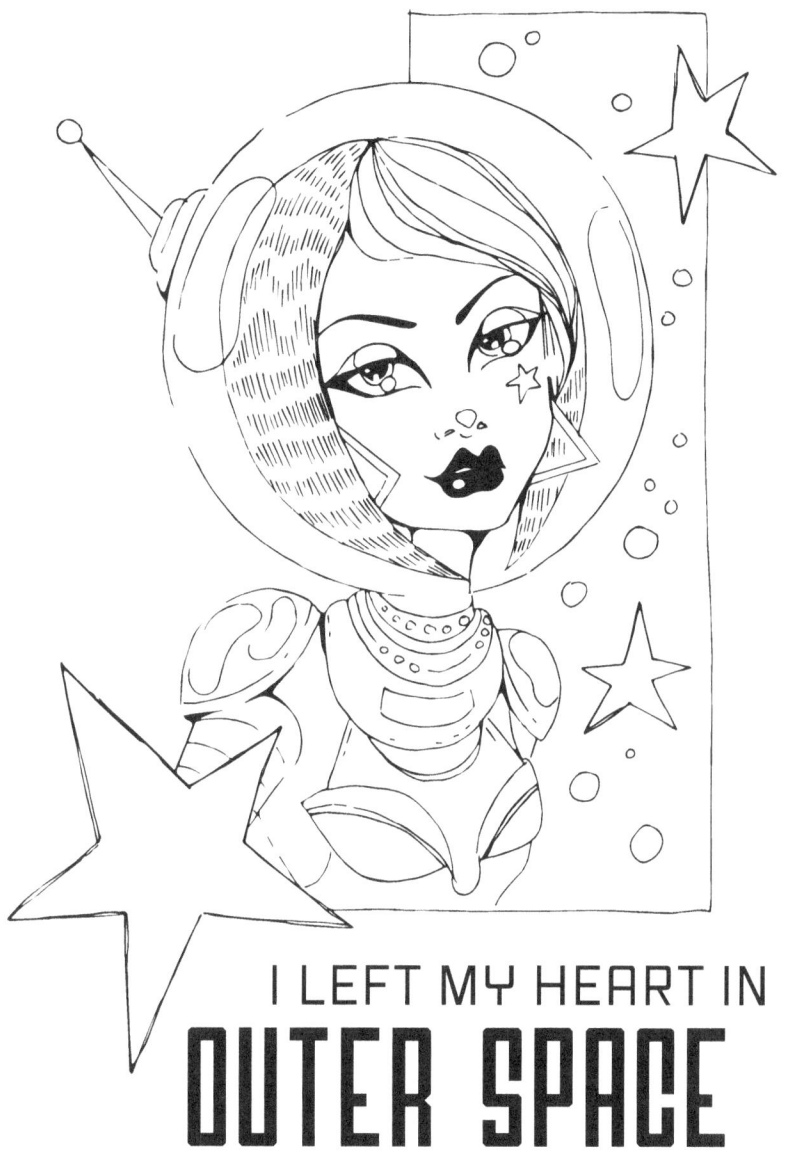

I LEFT MY HEART IN
OUTER SPACE

JOIN ME ONLINE

FACEBOOK | artistkarlamagana
INSTAGRAM | karla_magana

#stardustspacelustcoloringbook
to share your pages!

OTHER BOOKS IN MY UNIVERSE

www.ingramcontent.com/pod-product-compliance
Lightning Source LLC
Chambersburg PA
CBHW081615220526
45468CB00010B/2883